Mario Henri Chakkour

Photography by Missy Loewe

CD-ROM produced by Gregory Scott Wills

Virtual Pose®2

The Ultimate Visual Reference Series for Drawing the Human Figure

MAC/PC CD-ROM
ENCLOSED

DESIGN
BOOKS
INTERNATIONAL
Sarasota, Florida

VIRTUAL POSE® 2
The Ultimate Visual Reference Series for Drawing the Human Figure

by Mario Henri Chakkour

Published by
Design Books International
5562 Golf Pointe Drive, Sarasota, FL 34243 USA
TEL 941-355-7150 FAX 941-351-7406

Distributed by
North Light Books, an imprint of F&W Publications, Inc.
1507 Dana Avenue, Cincinnati, Ohio 45207
TEL 513-531-2222, 800-289-0963

Creative Direction: Mario Henri Chakkour
Art Direction: Stephen Bridges
Design: Beth Santos
Photography: Missy Loewe
Female Models: Kimberly Kelley, Alice Marie, Alana Neis, Laurie Wallace
Male Models: James Marino, Christopher West
CD-ROM Produced by Gregory Scott Wills

Music by EmZ™

Visit us on the Web @ www.virtualpose.net

ISBN 0-9666383-5-2

05 04 03 02 01 5 4 3 2

Printed in Hong Kong

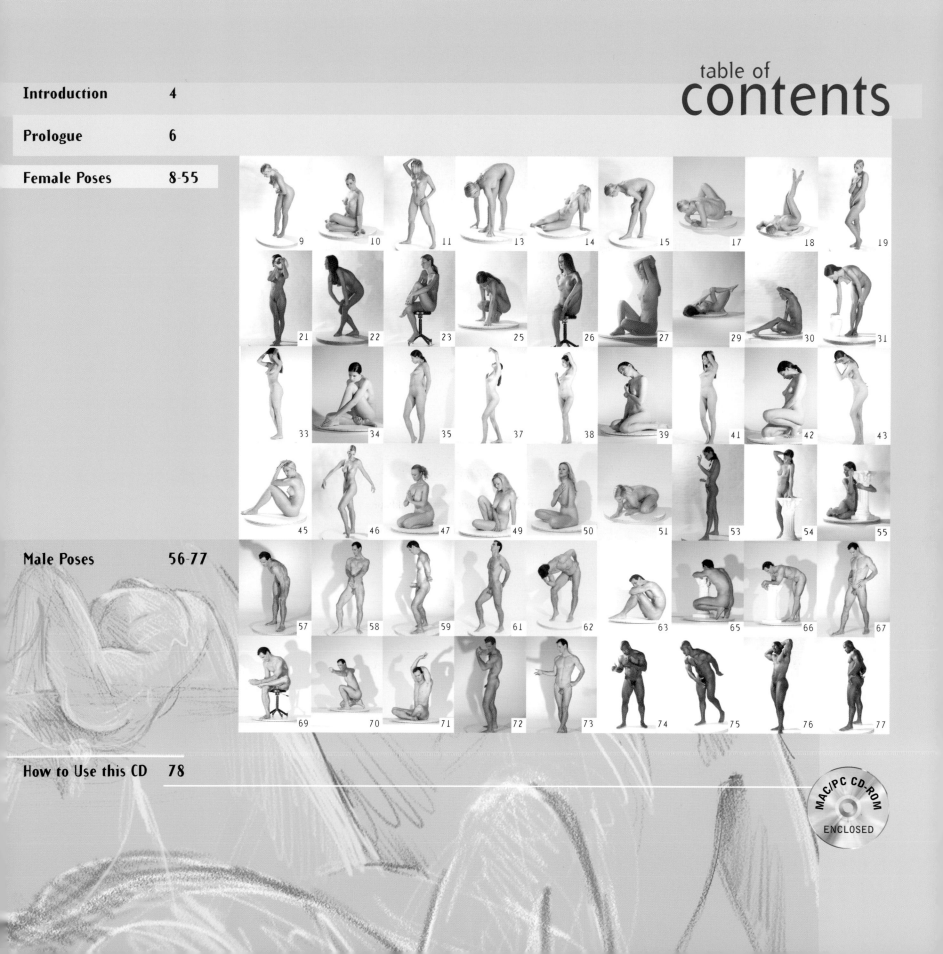

table of
contents

MAC/PC CD-ROM
ENCLOSED

When Gregory Scott Wills and I set out to redefine the way artists use visual reference guides to draw the human figure, I remembered the life drawing sessions with a figure model I hired regularly back in my student days. Working in a modest studio, permeated by the sweet smell of chocolate from the confectionery factory next door, I felt a sense of urgency to capture the essence and the magic of the moment.

I also remembered the sense of awe I used to feel when visiting the Dahesh Salon, in Beirut, as a child. It was the total experience when looking at the art collection... the gentle sea breeze, the sweet smell of fruit, and the fountain... sounds and images forever etched in my memory.

Therefore, when Greg and I asked ourselves if artists would take to *Virtual Pose* — a product which would allow them to practice figure drawing by rotating models 360 degrees right on their computer screen — we knew this would work provided we offer a totally engaging experience.

By combining the right ingredients and by becoming more than a mere collection of poses, Virtual Pose pays homage to that moment which could only be experienced first hand, thus becoming a catalyst for participation.

For the more practical souls, this sequel offers a greater number of poses and models to choose from. Missy Loewe's masterful eye and passionate attitude towards her craft, not only captured the essence of the moment, but resulted in a truly outstanding record in the history of this project.

Plus, by popular demand, we placed even more emphasis on the tutorial section, thus offering both teacher and student an even greater resource. Last but certainly not least, you will find a catalog of musical themes composed over the years which were produced especially for this occasion. We proudly feature flute virtuoso, maestro Matus Betko. His lyrical passages will, once again, inspire you to draw, paint and sculpt, as the revolution continues!

MARIO HENRI CHAKKOUR

When people can't help but feel compelled to caress my sculpture, when they move the palm of their hand over the smooth curved surfaces, or when they scan the rippling texture with their finger-tips where shadows are trapped, I enjoy their response and the glances between us.

I feel that... by first choosing an emotive pose for my model, building up the figure with clay, modeling or abstracting it—always loving the meaning of the pose and the sense of life-force, as the surface appears to be pushed from within... that part is done.

However, my sculpture is not yet finished until someone looks at it, responds to my statement, and shares in the pleasure of the tactile experience.

MIRELLA MONTI BELSHÉ

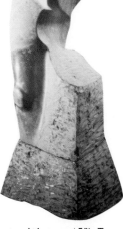

Figleaf 27"w x 37"h
(Back and side view)
© 1999 MIRELLA MONTI BELSHÉ

Becoming Woman 45"h Travertine
© 1998 MIRELLA MONTI BELSHÉ

Becoming Woman 45"h
Black Belgian Marble
© 1998 MIRELLA MONTI BELSHÉ

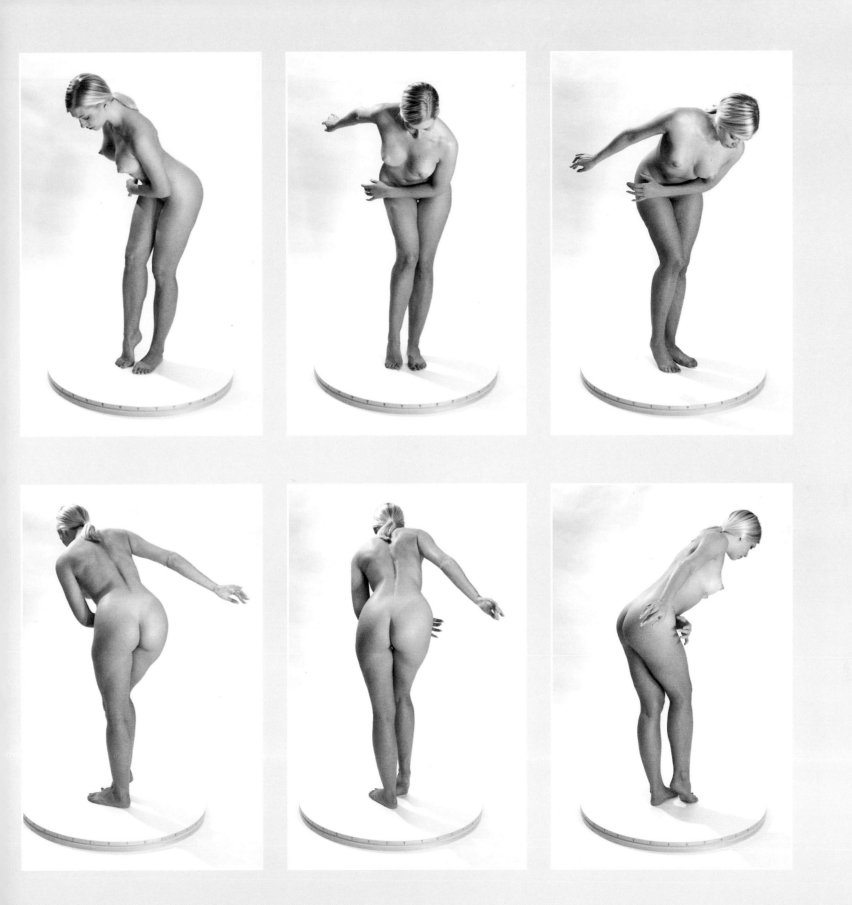

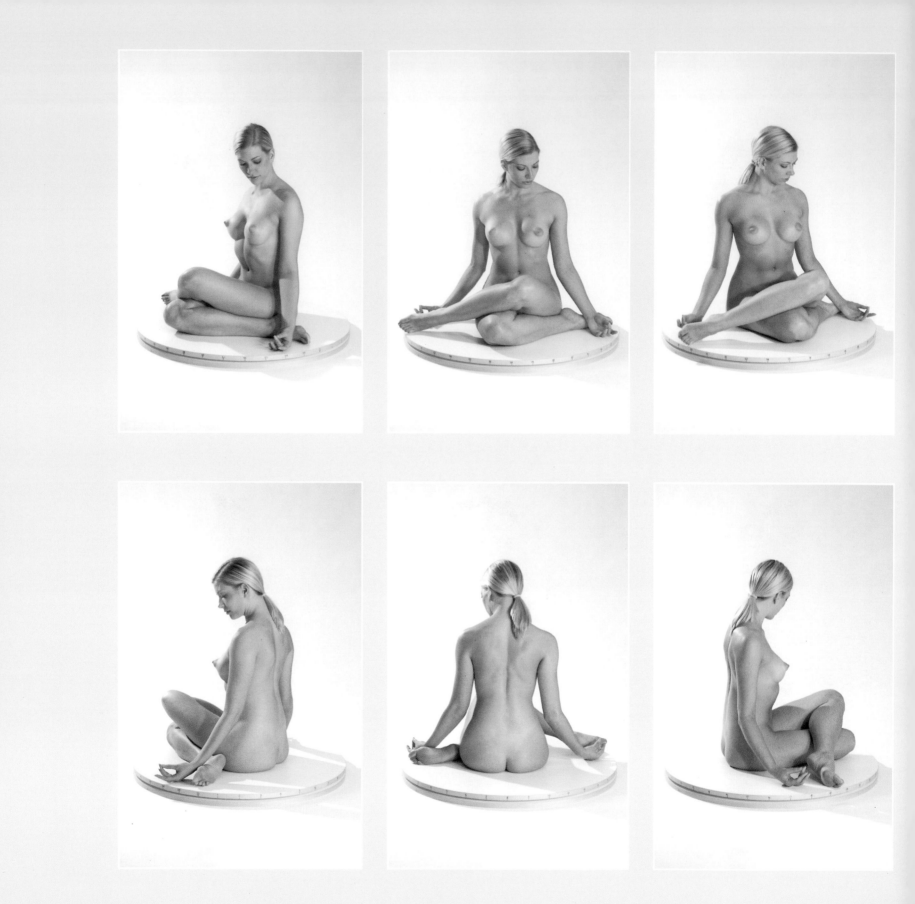

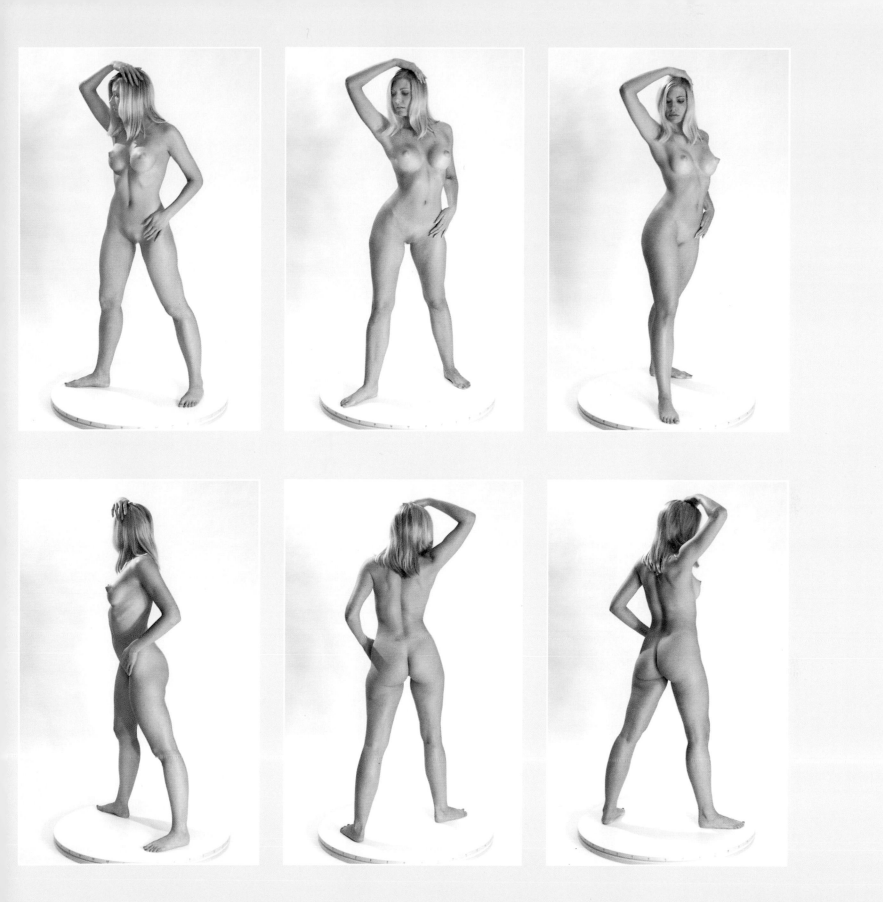

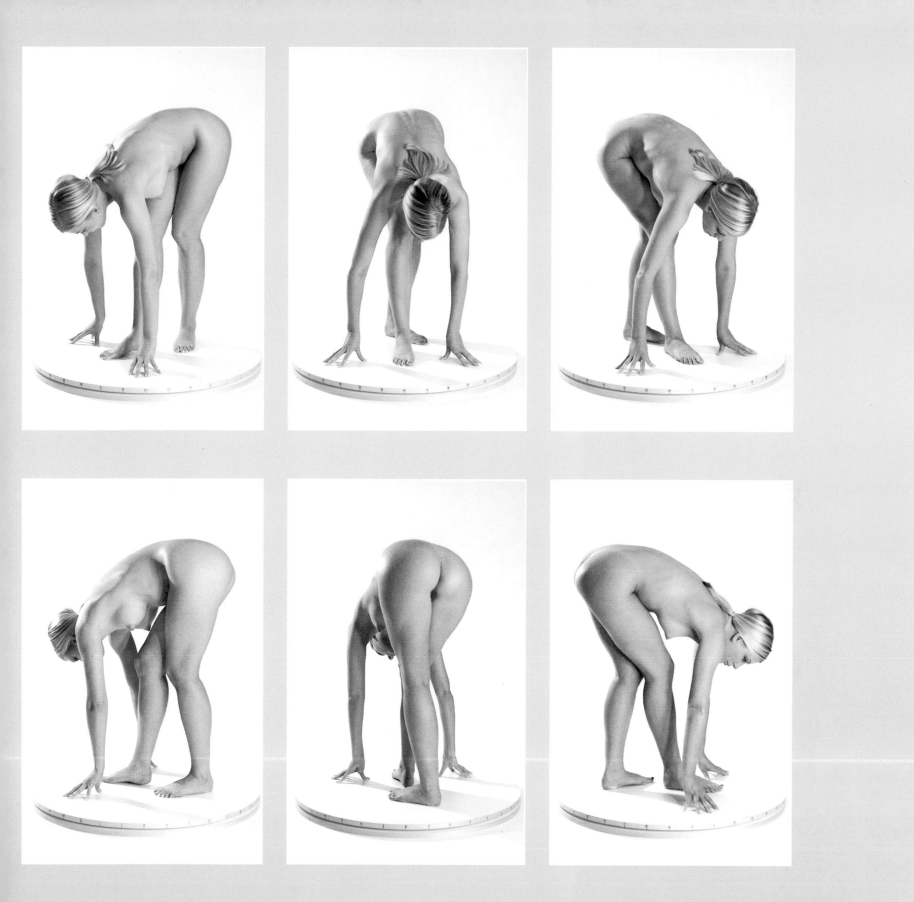

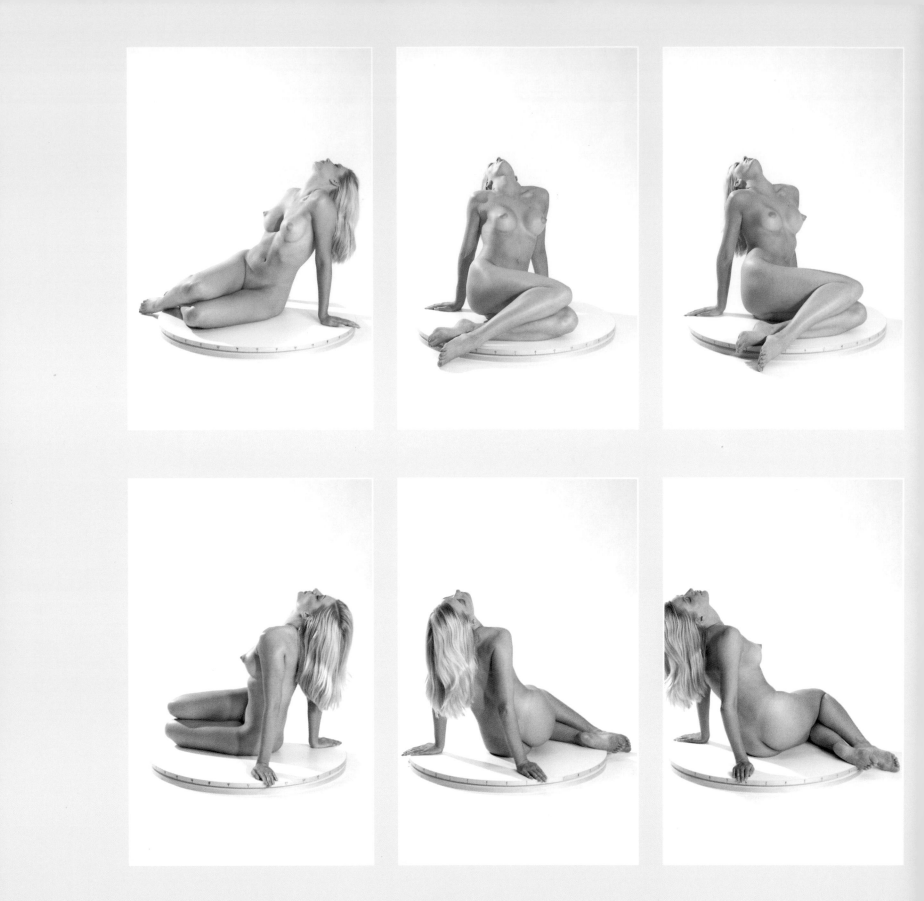

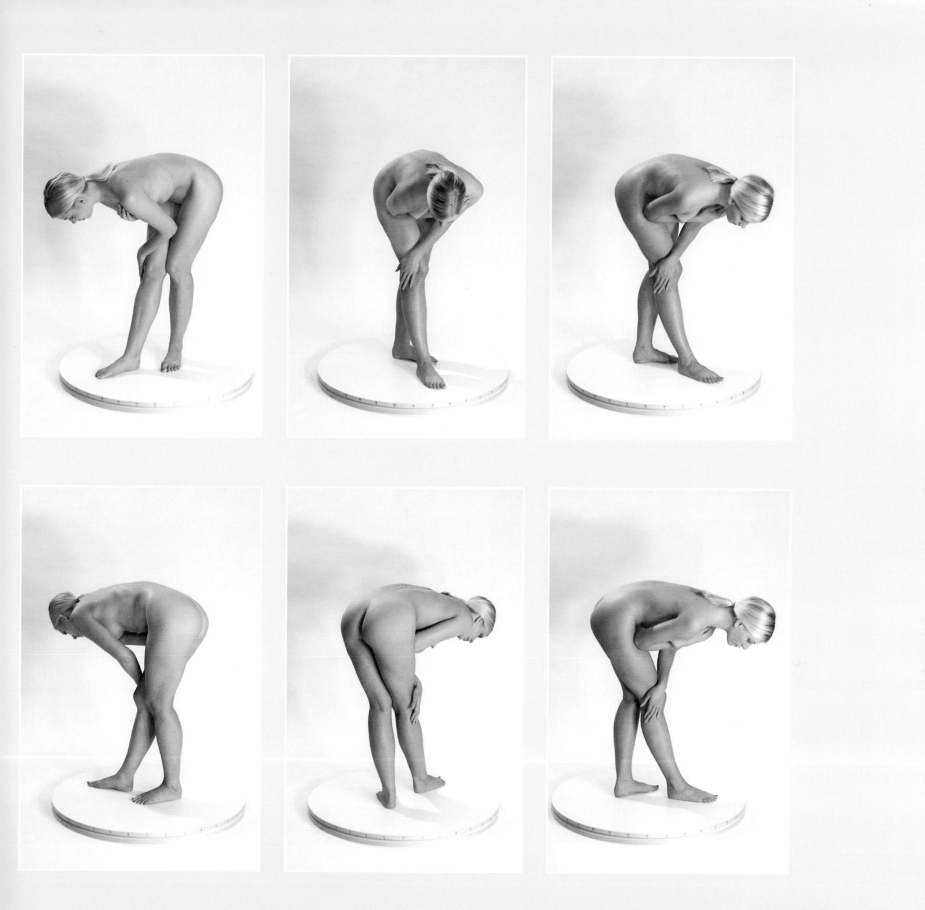

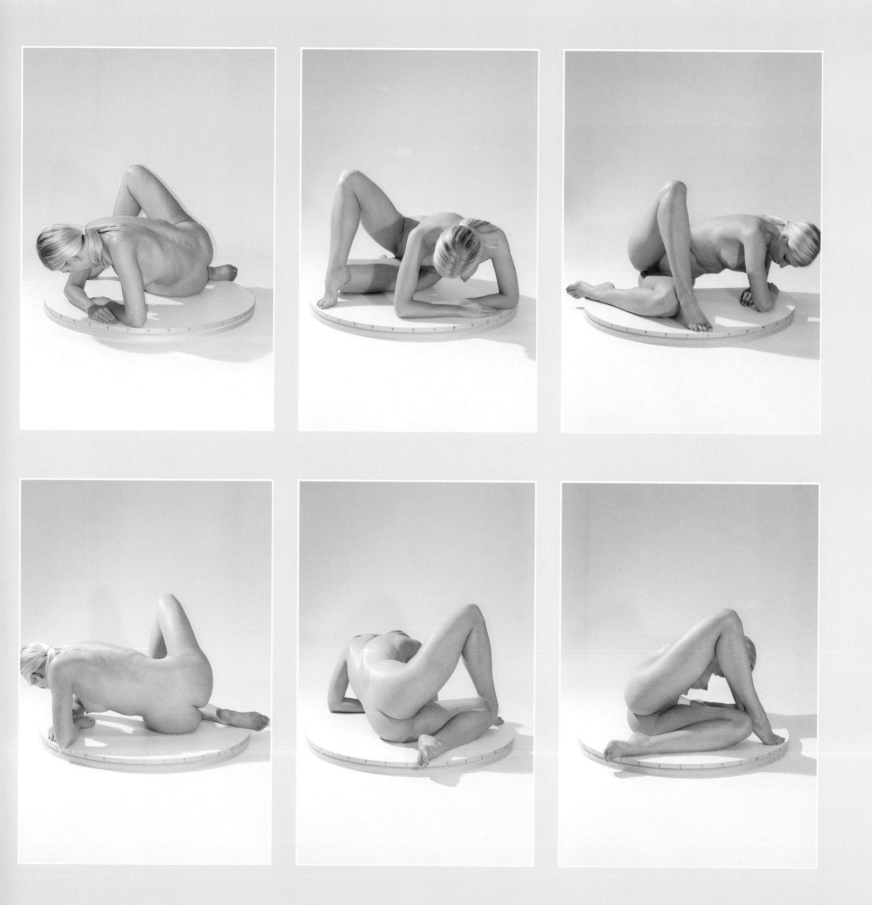

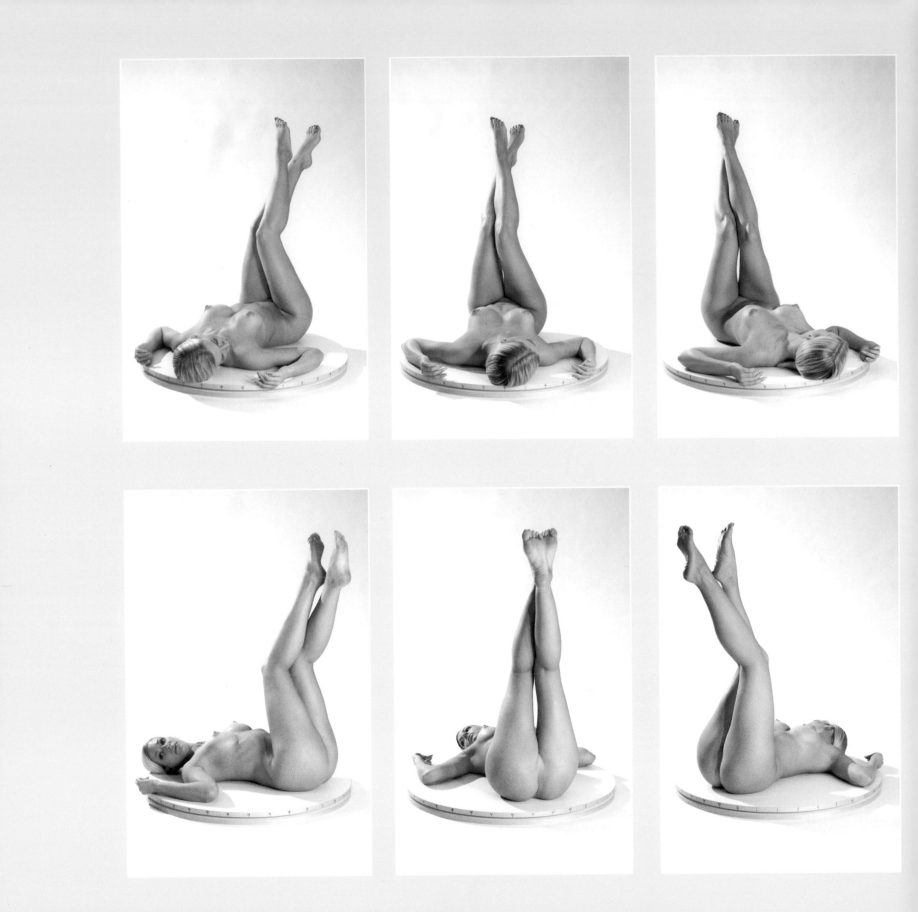

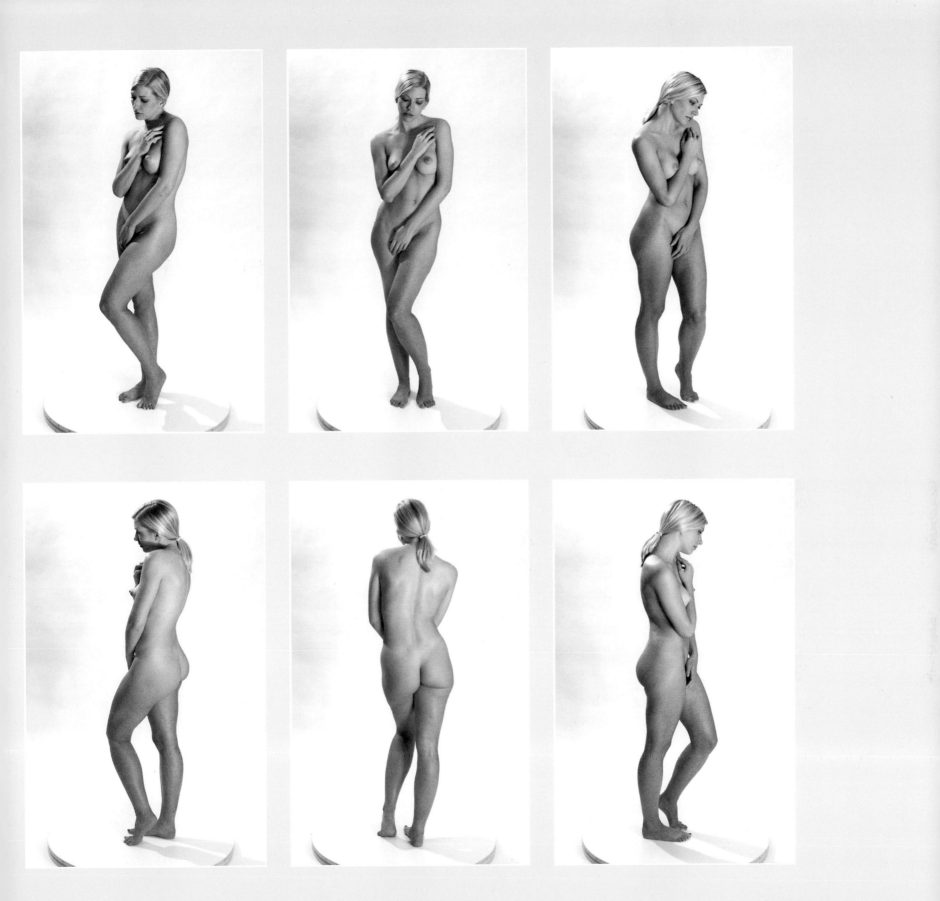

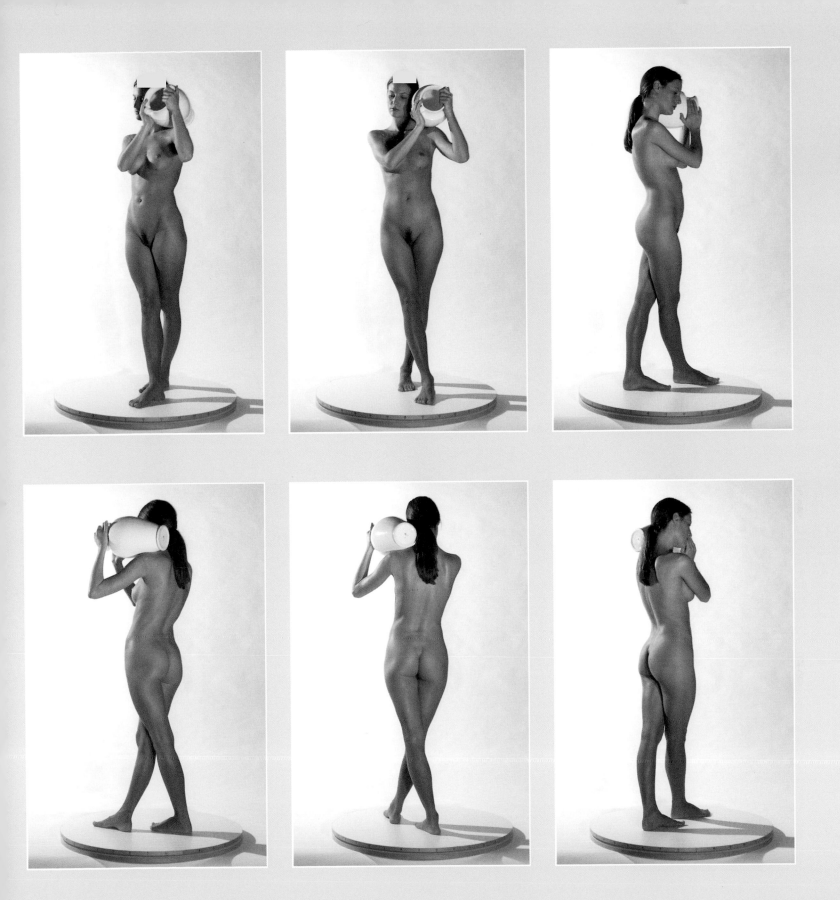

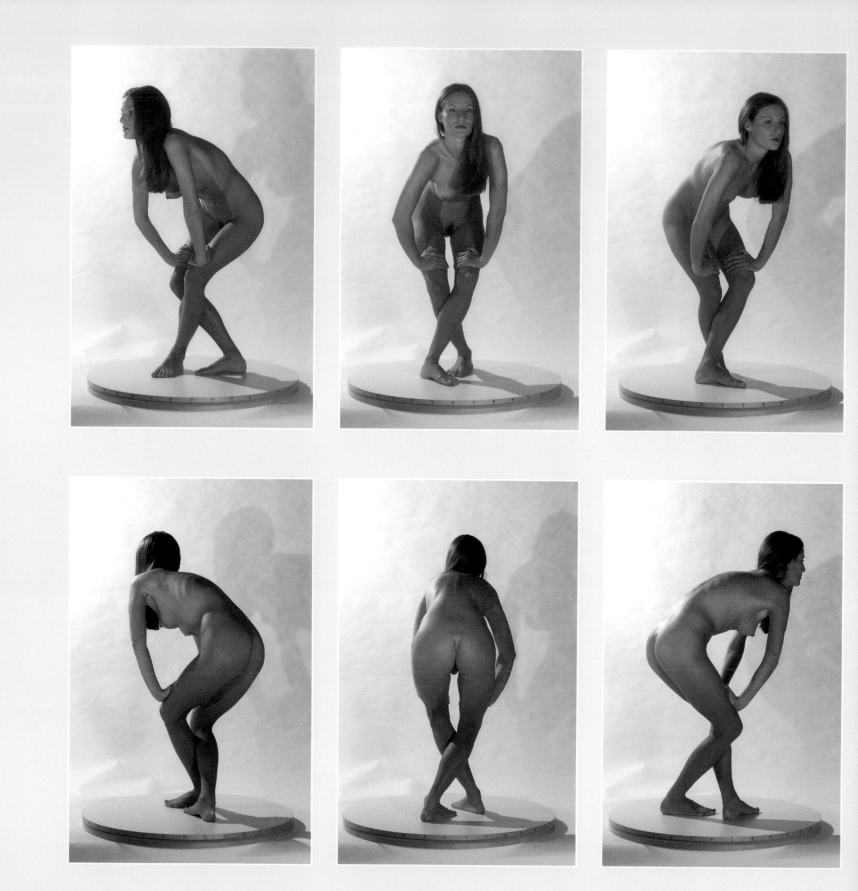

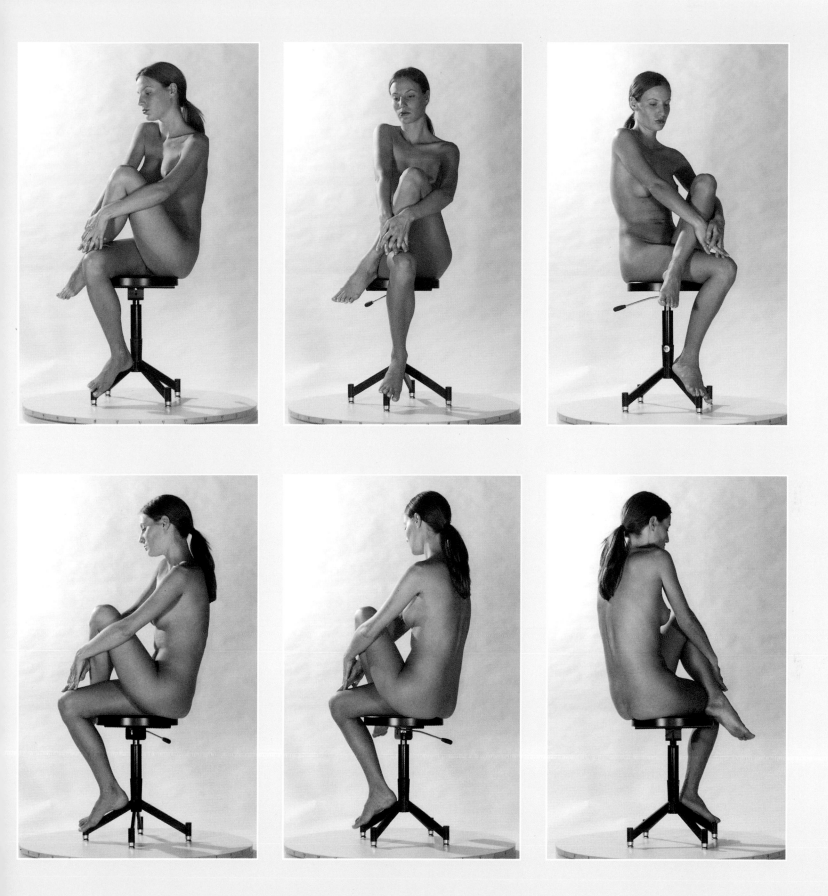

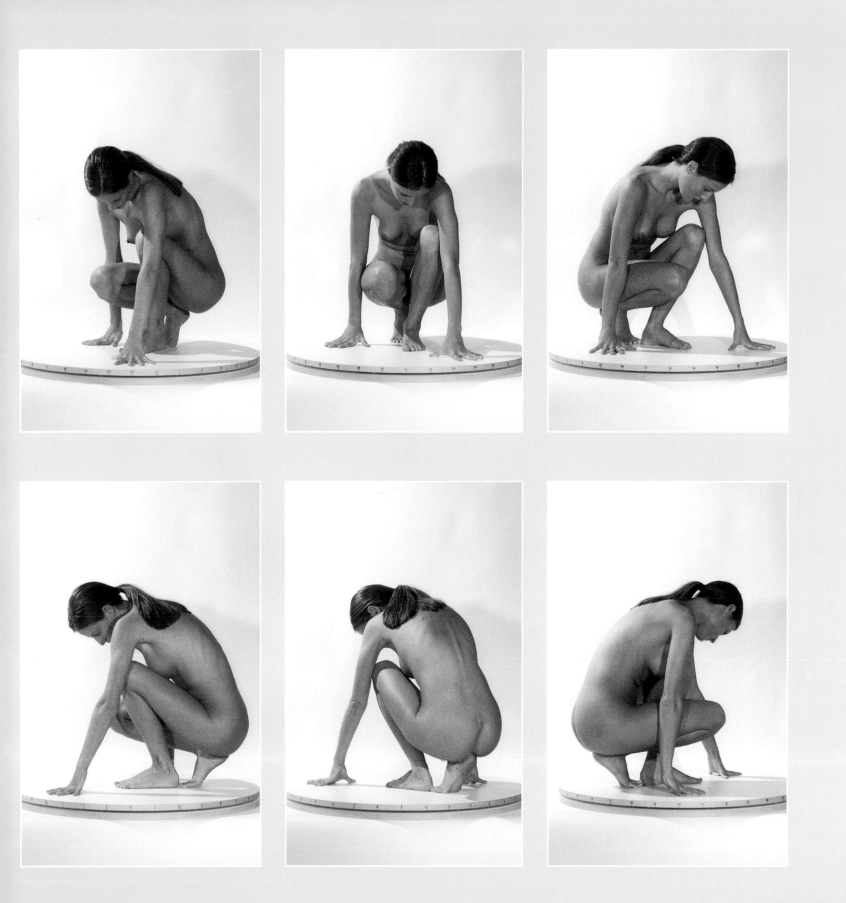

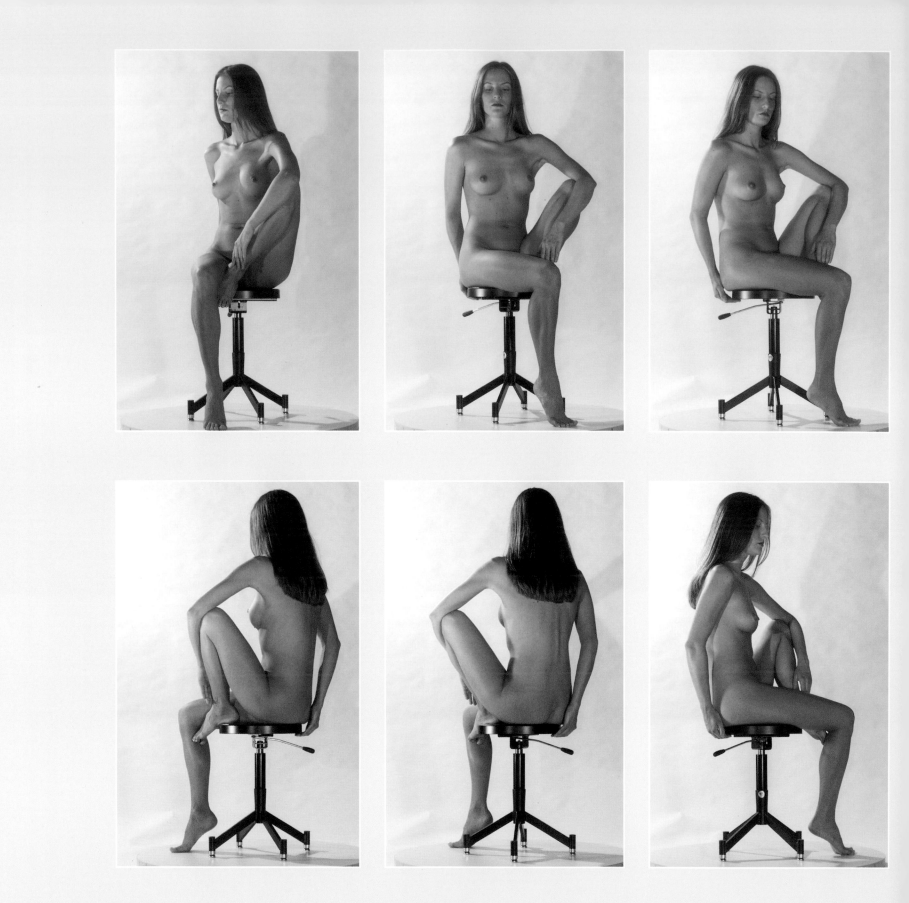

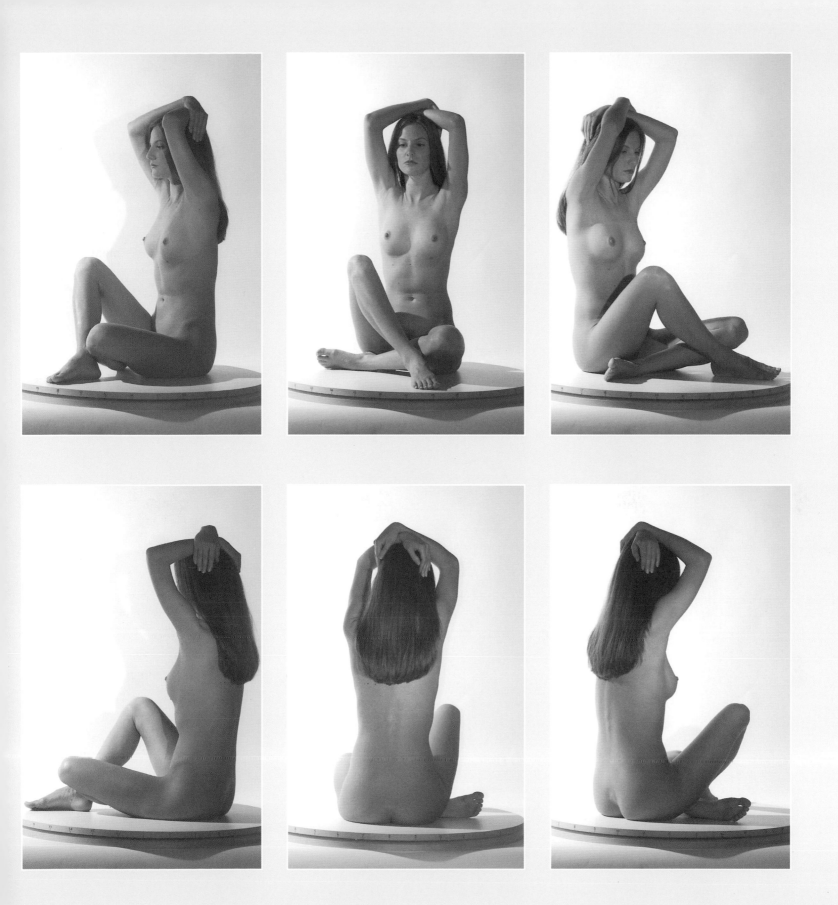

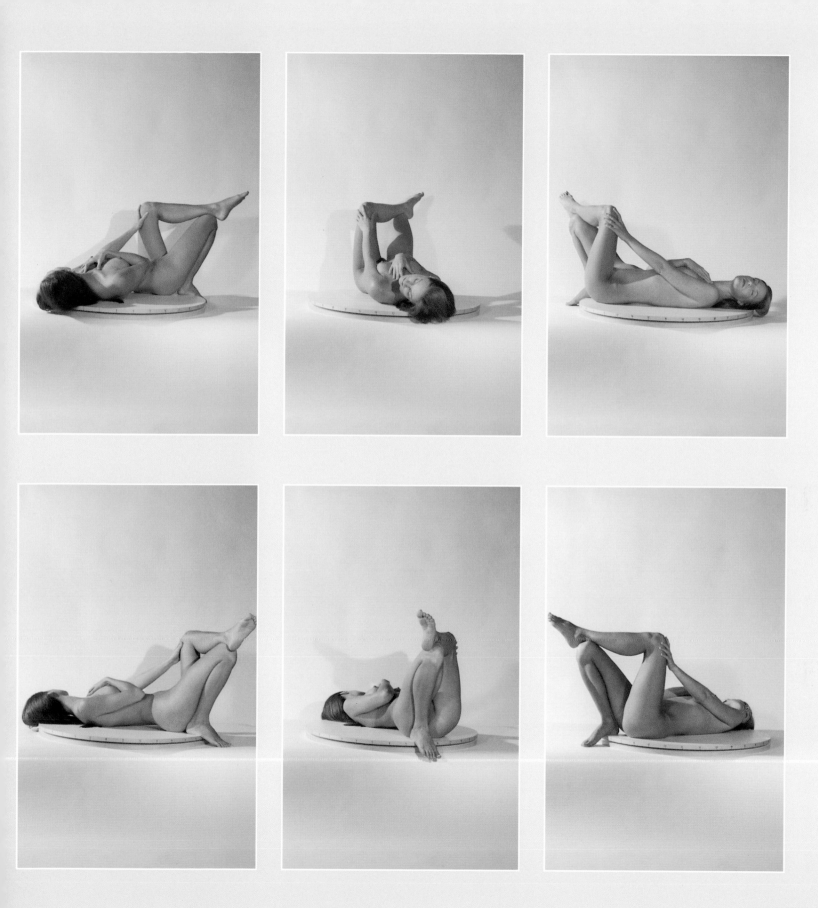

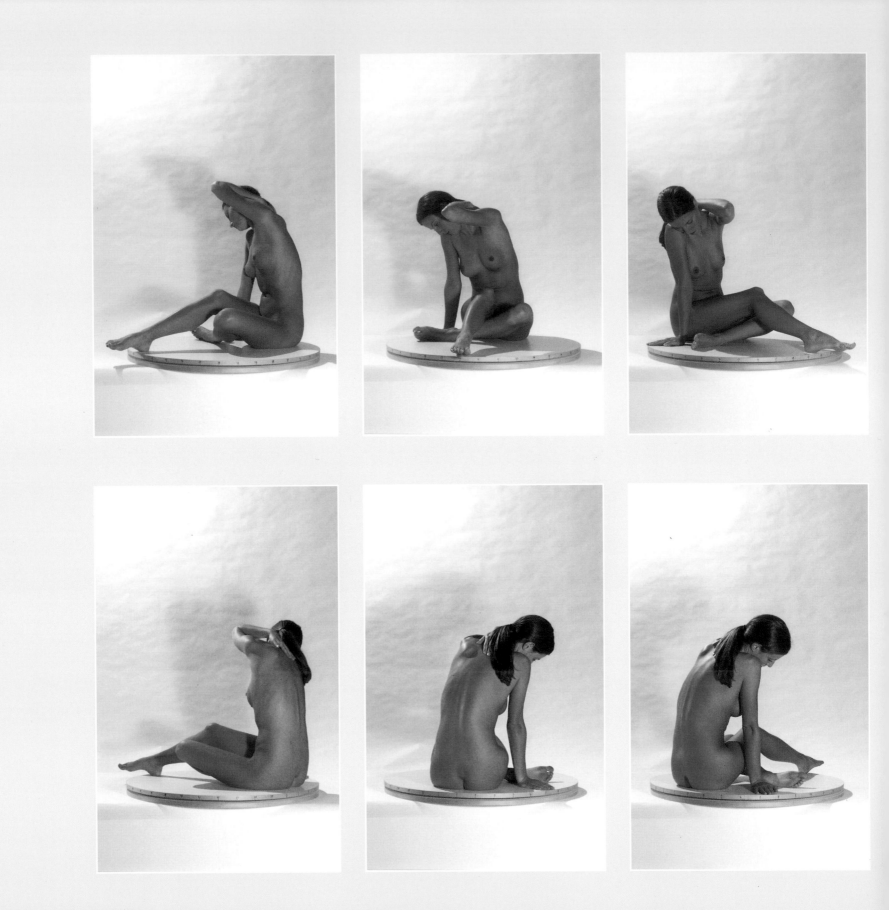

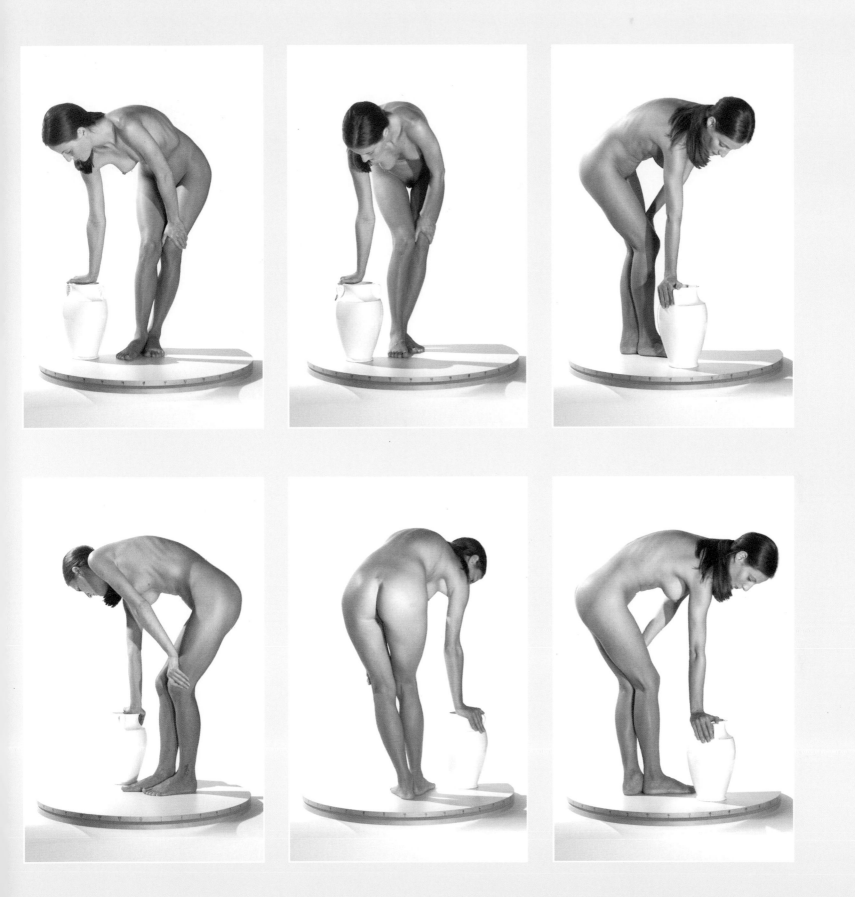

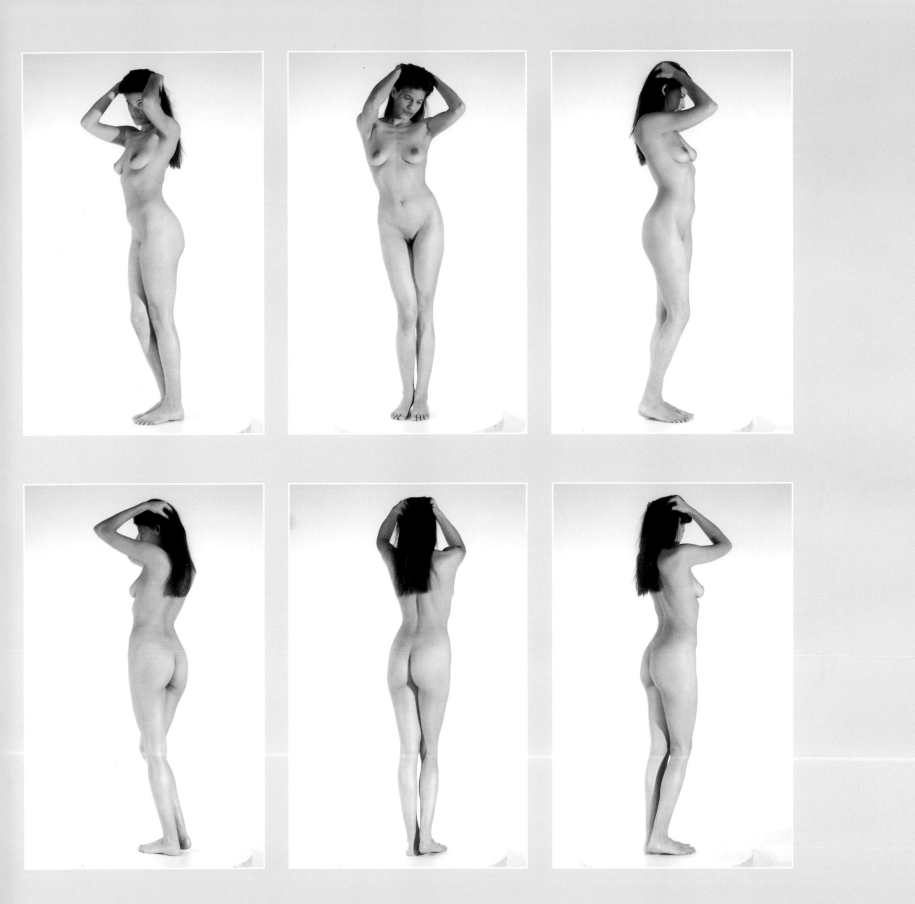

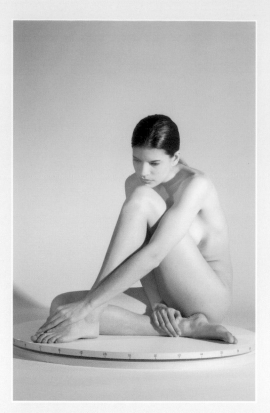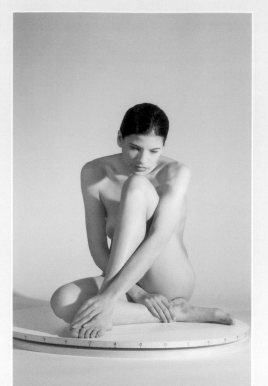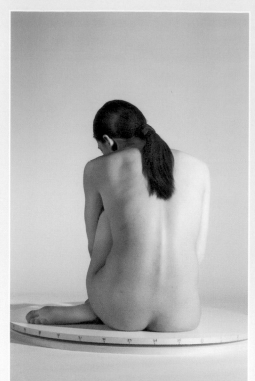

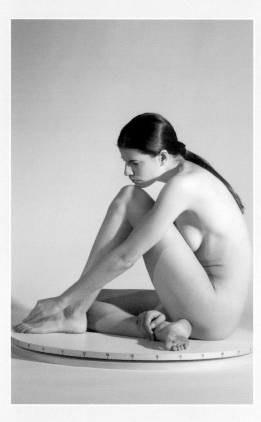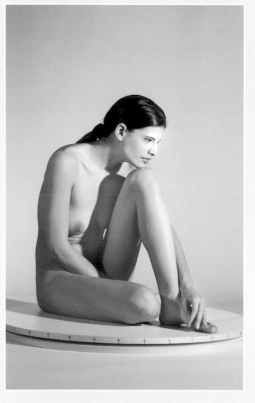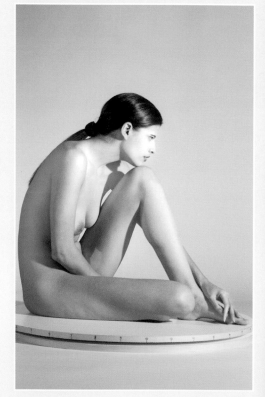

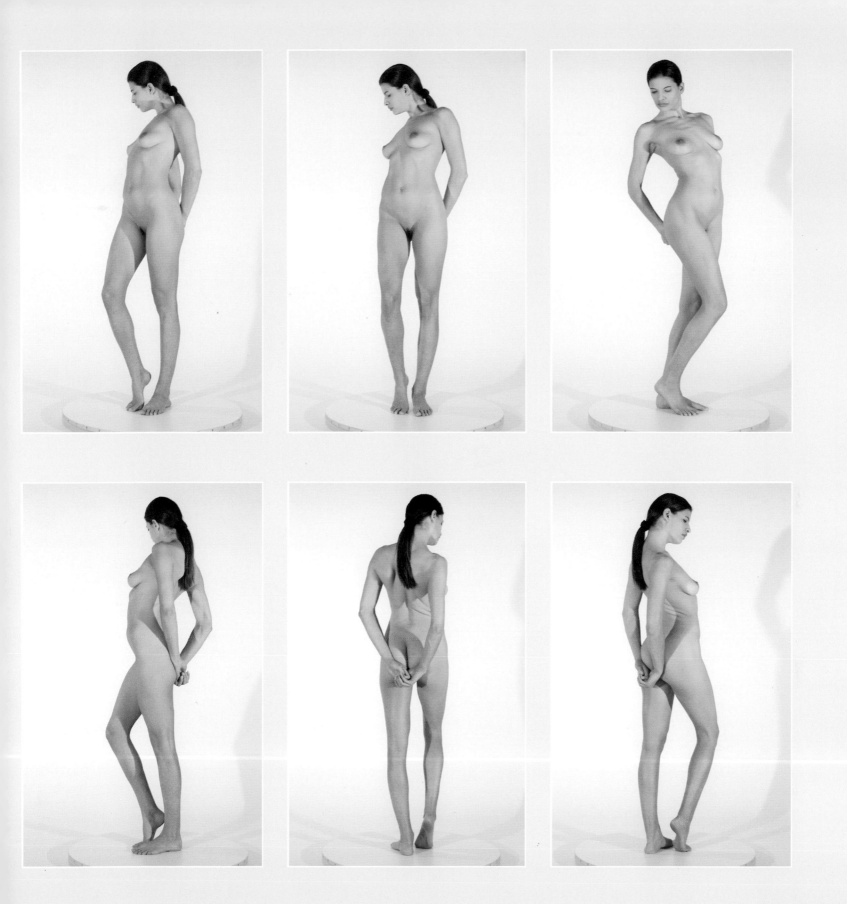

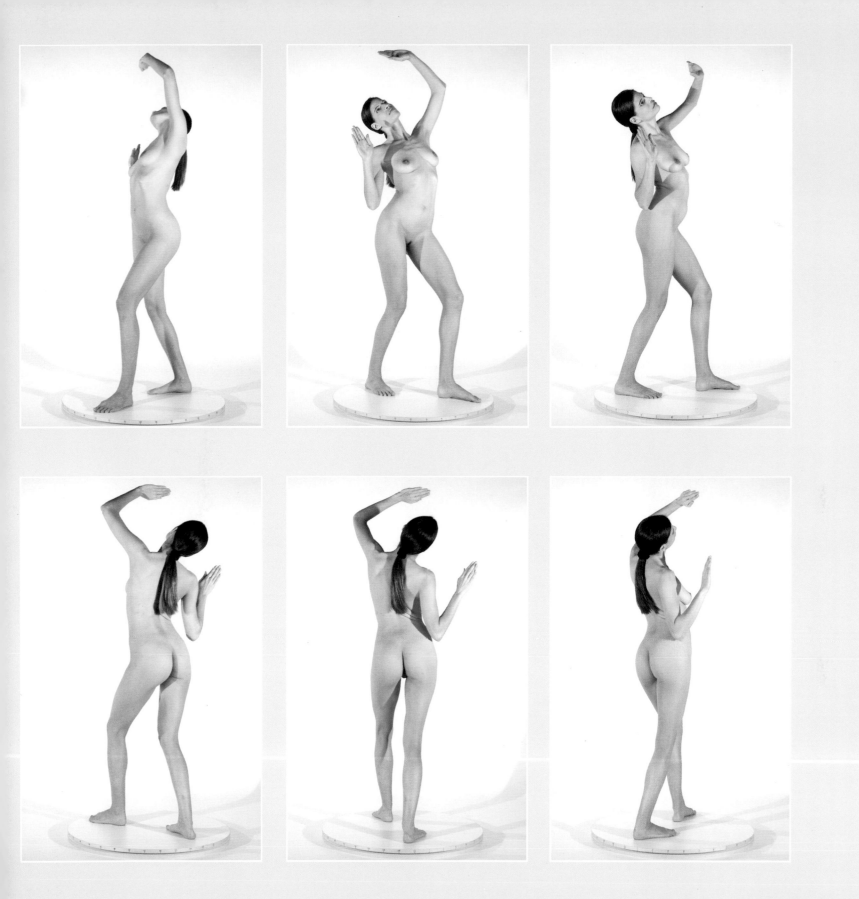

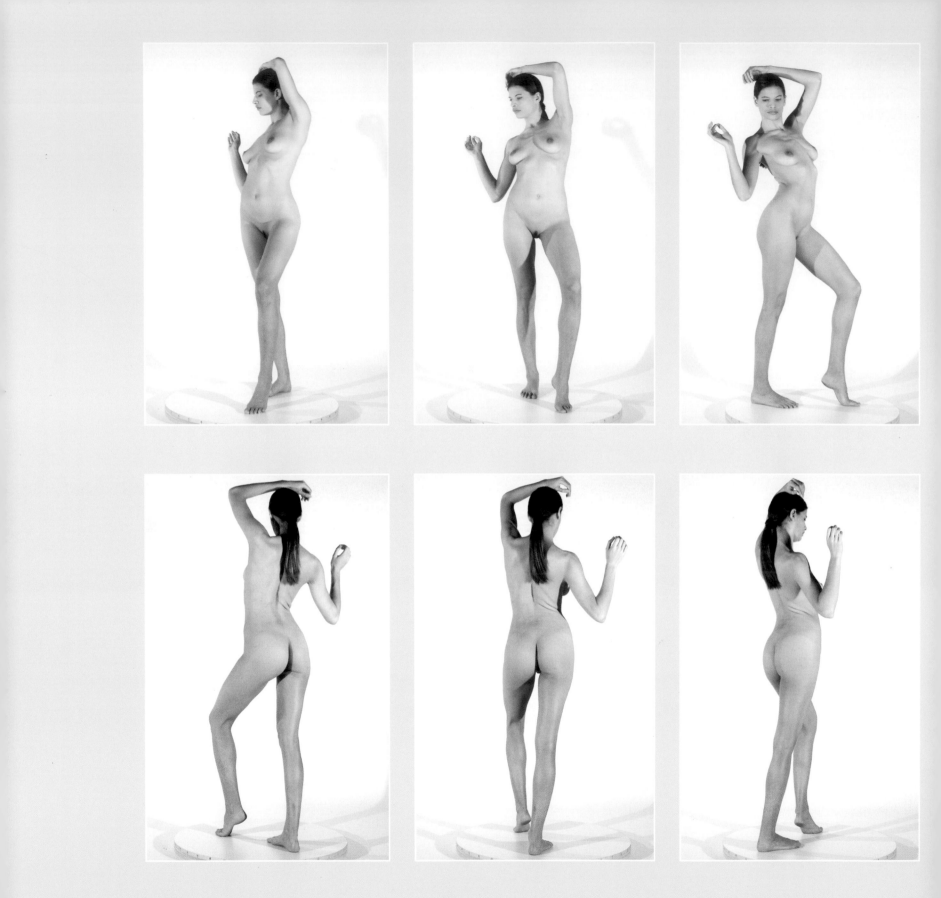

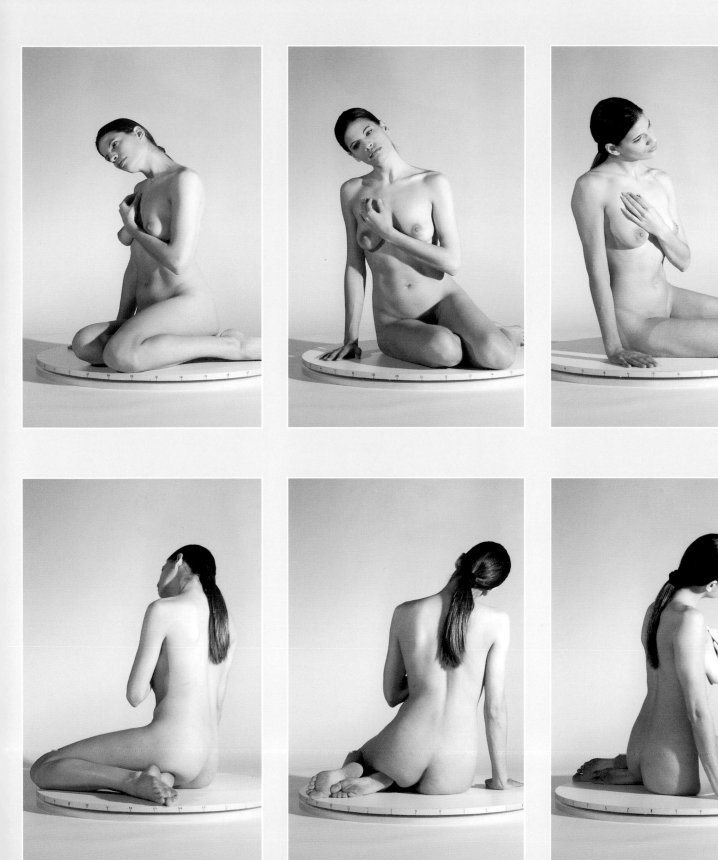

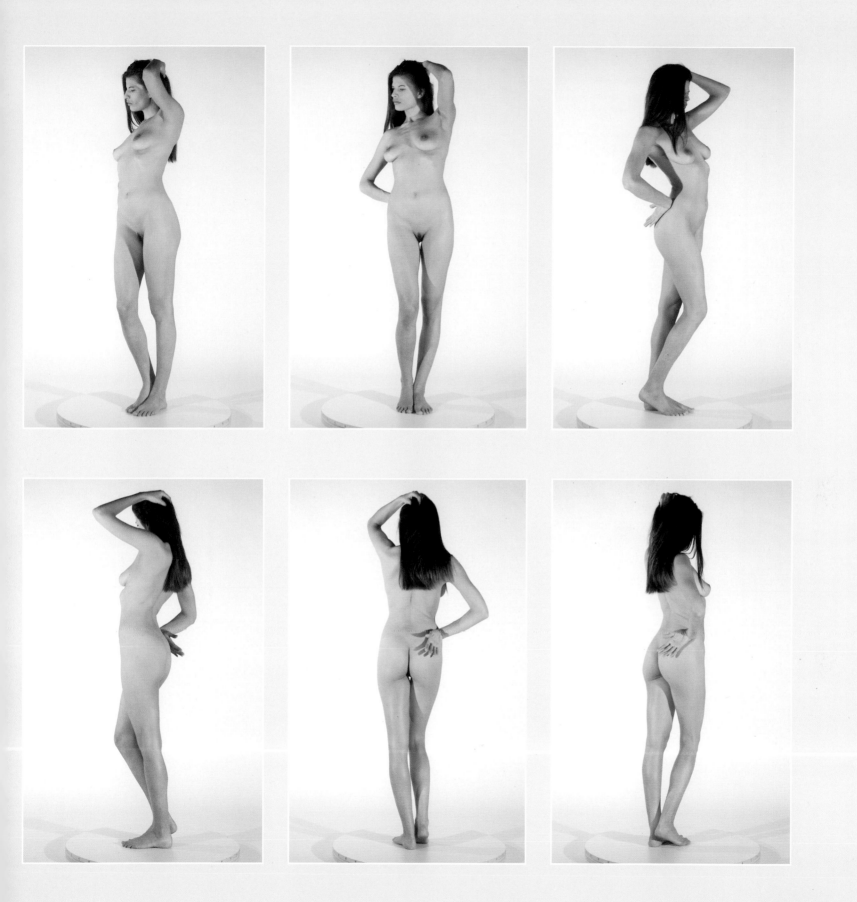

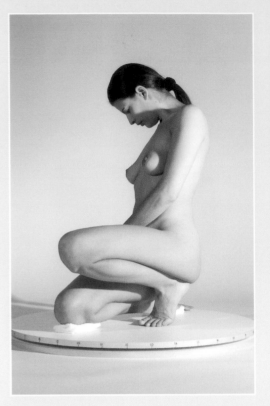

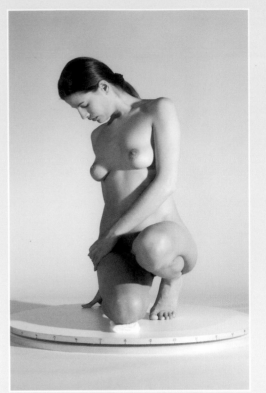

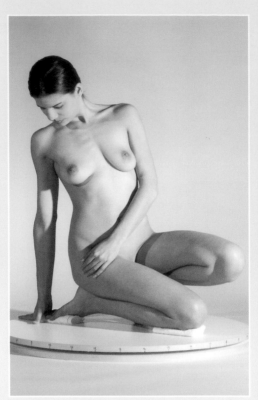

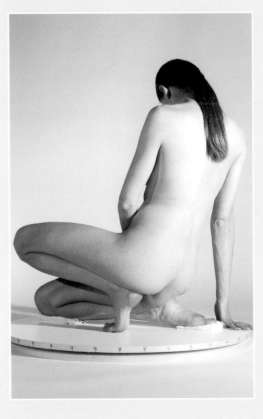

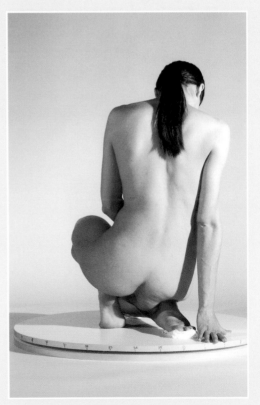

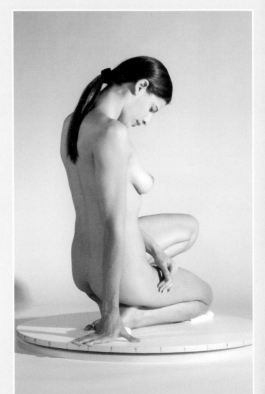

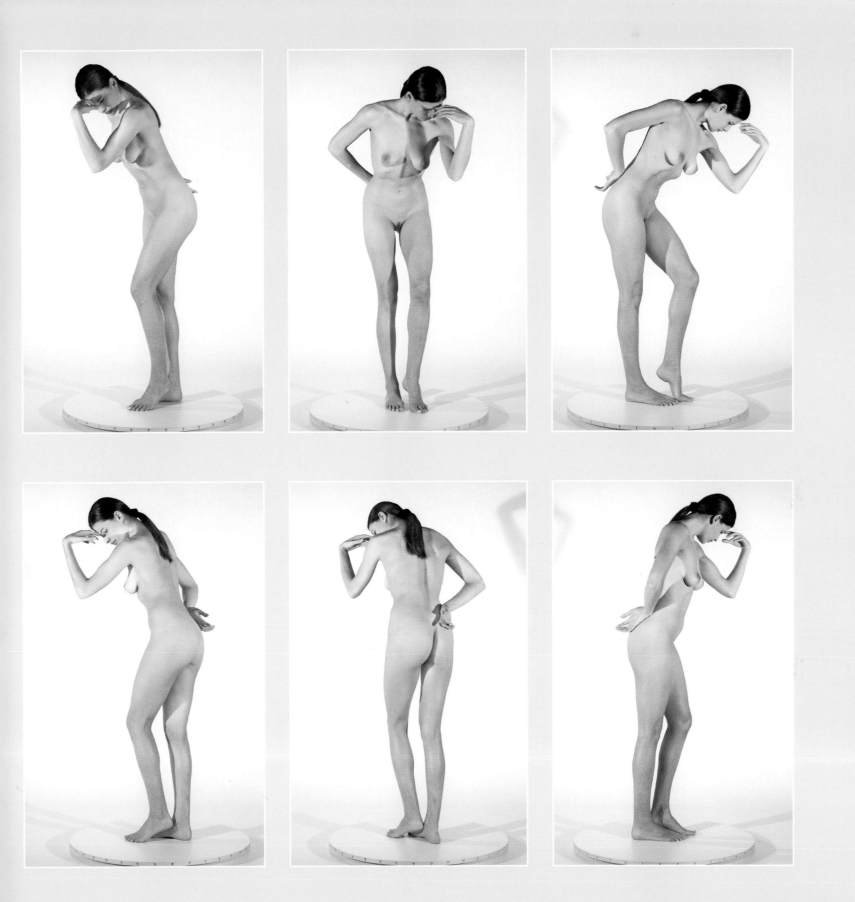

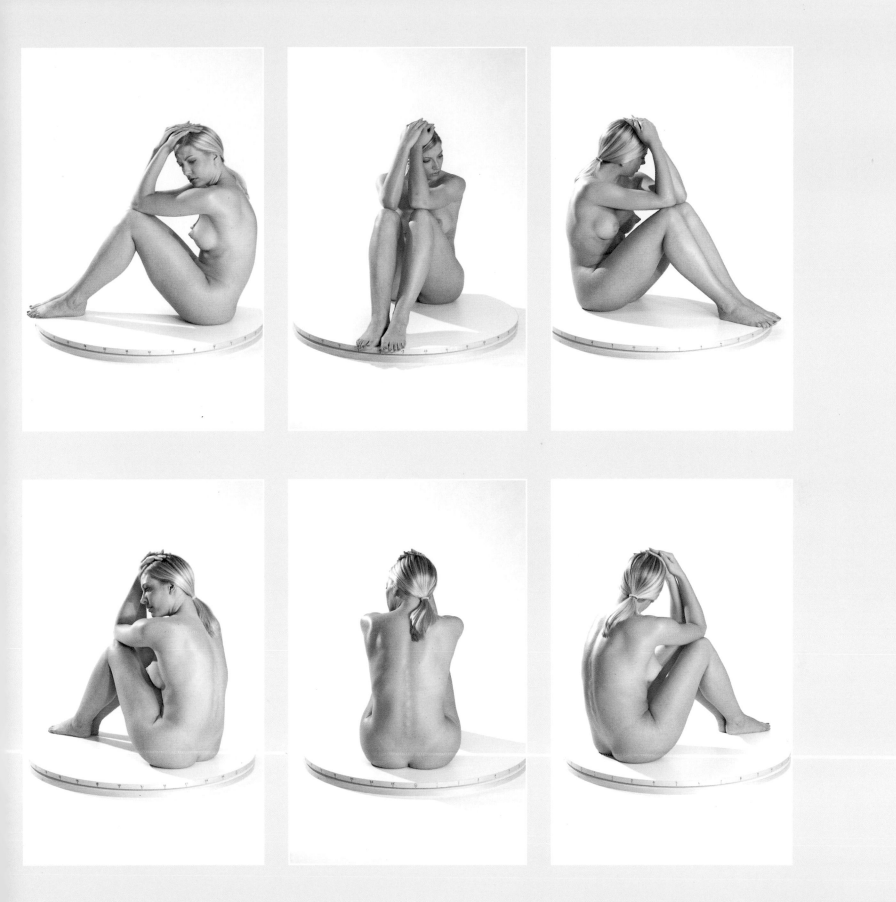

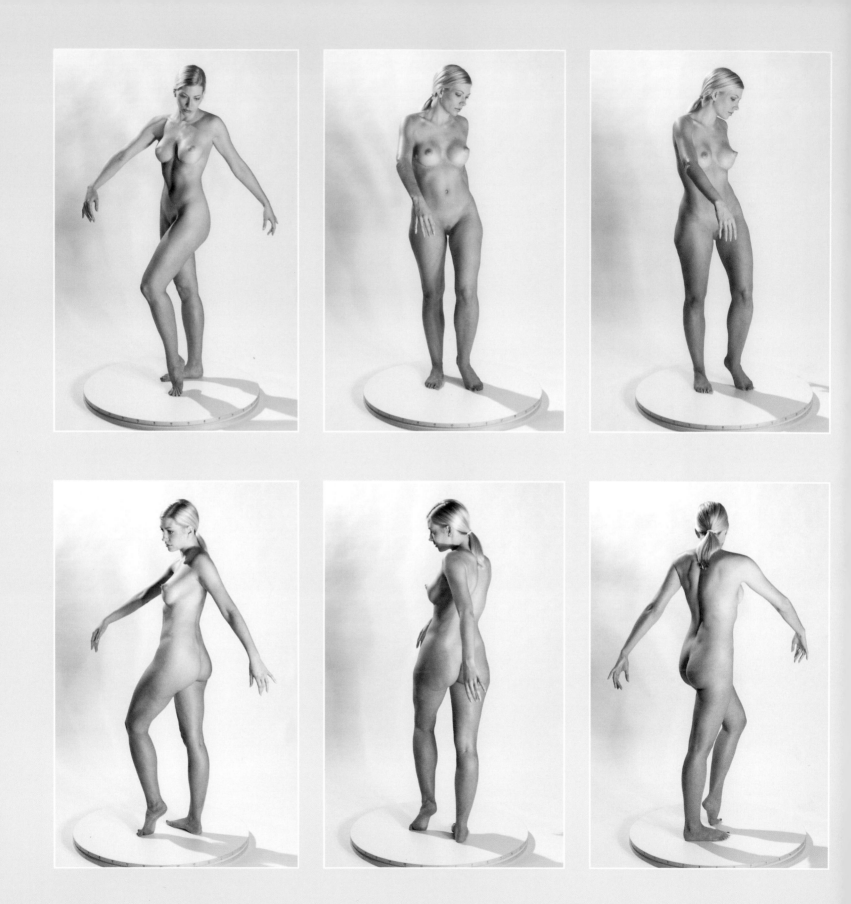

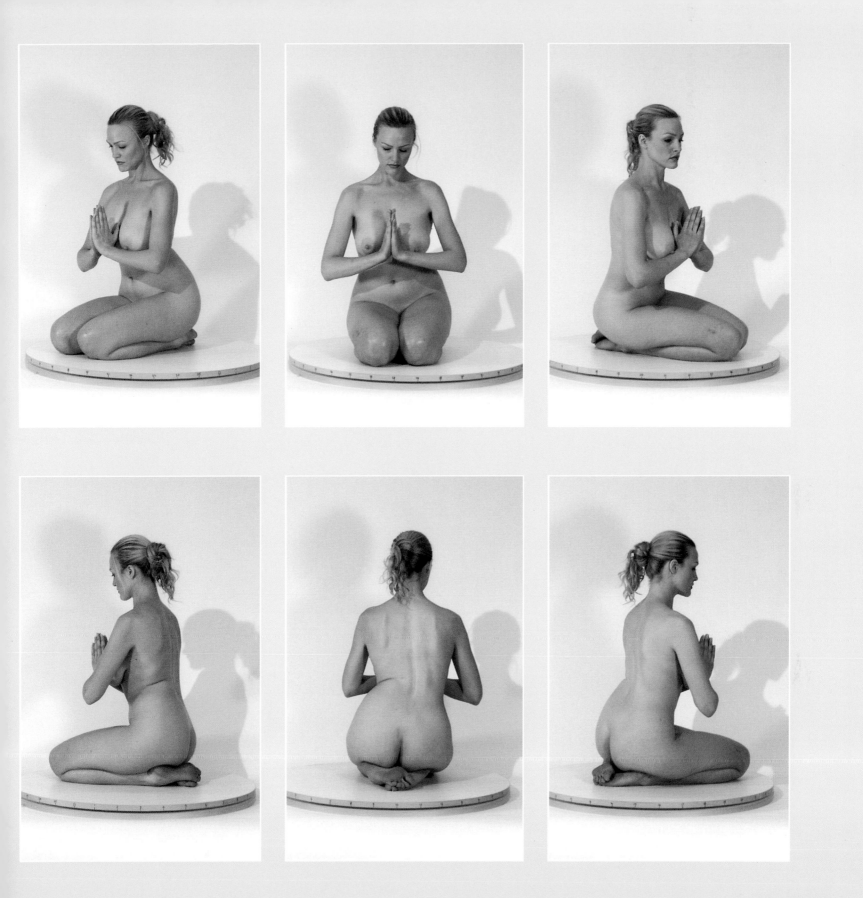

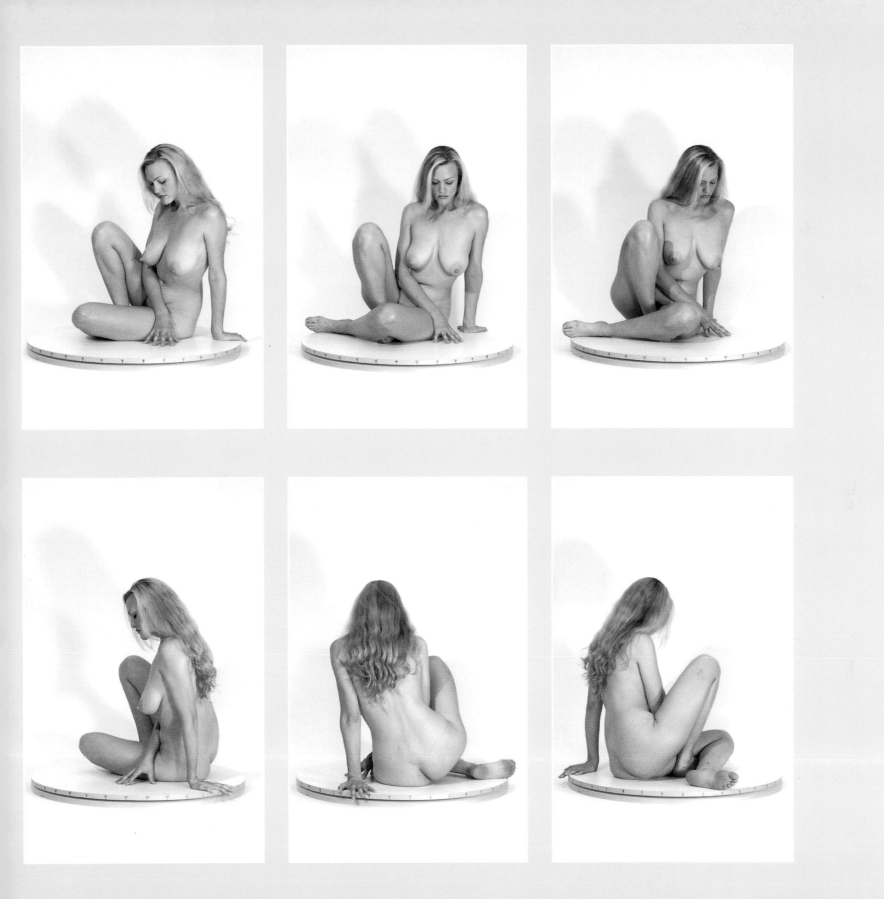

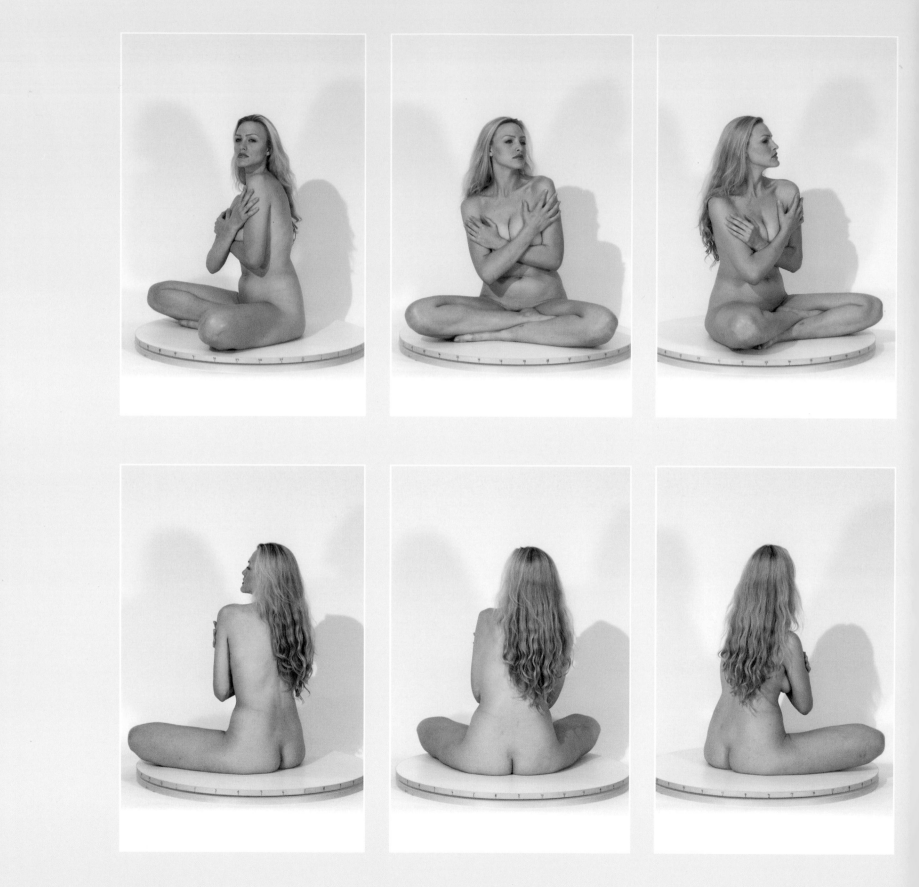

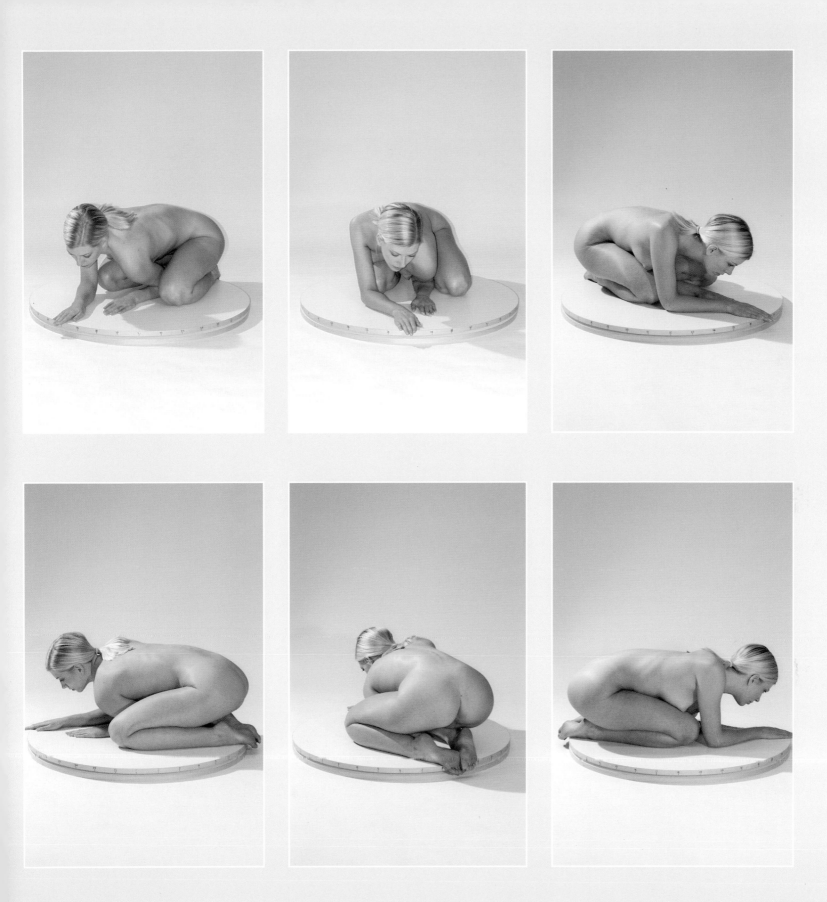

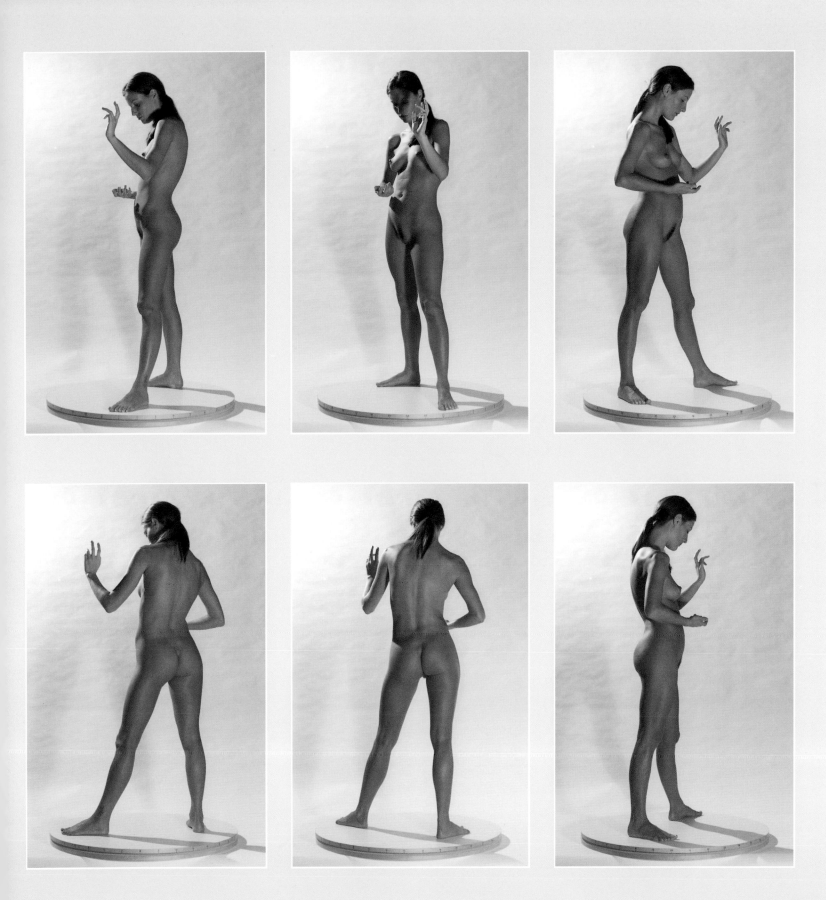

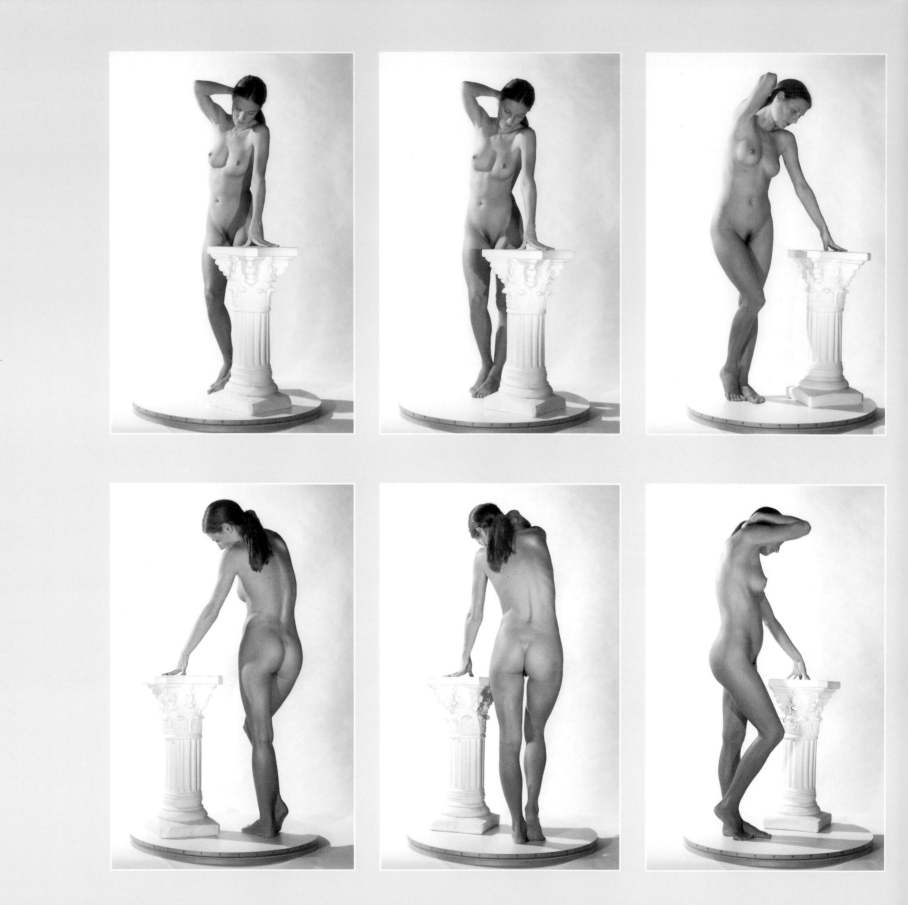

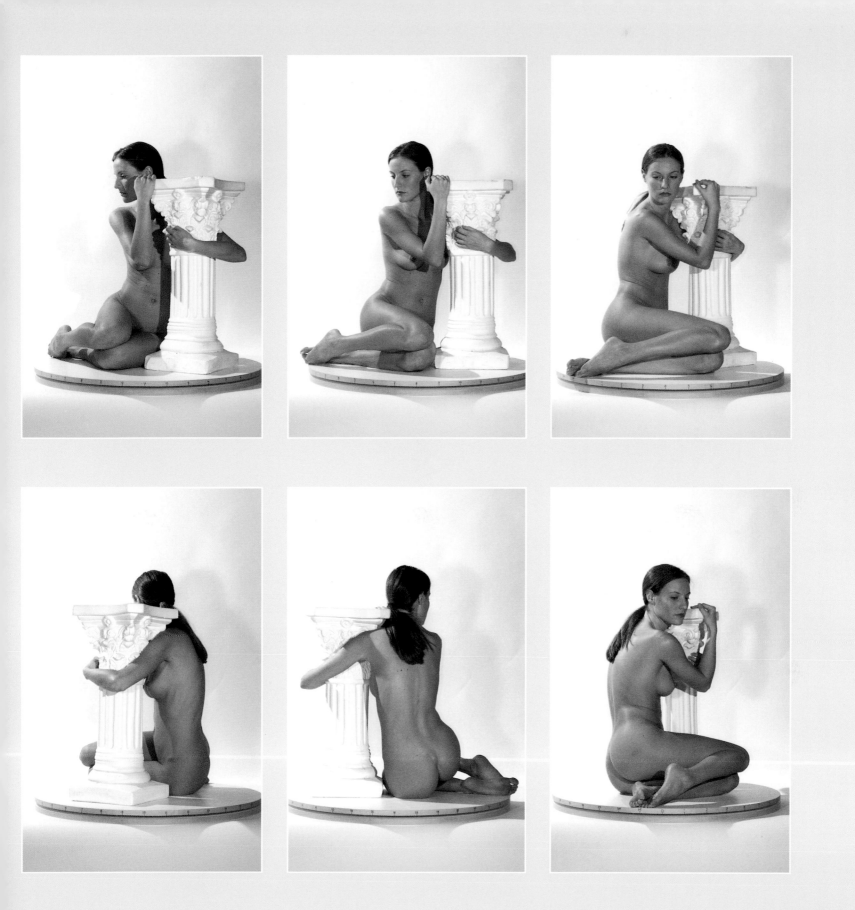

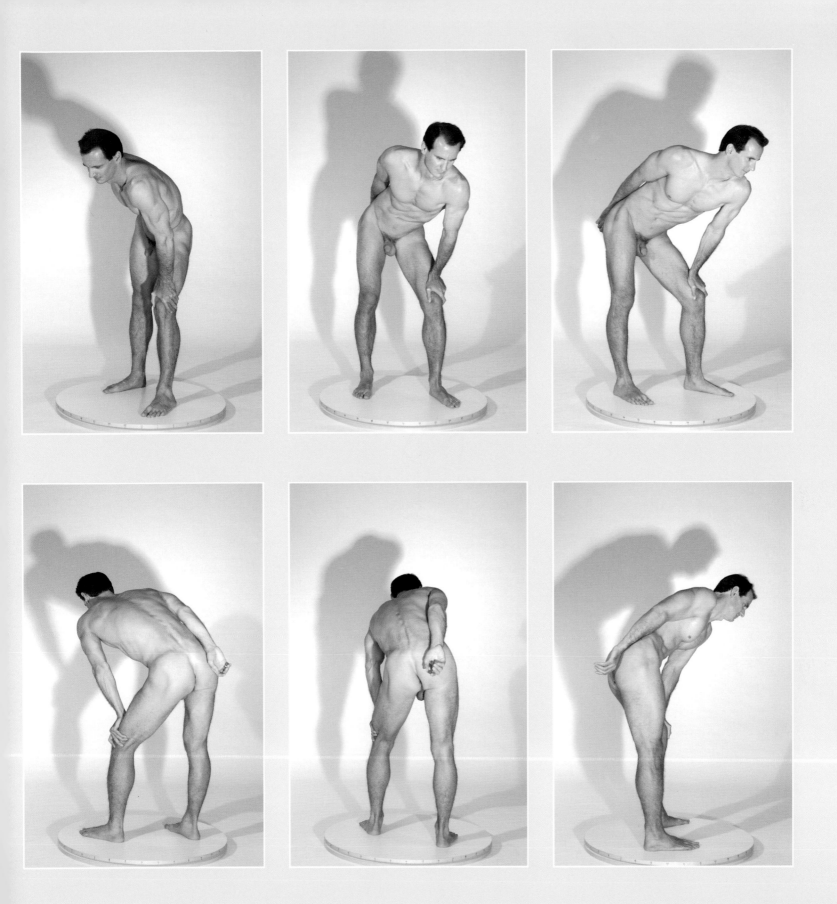

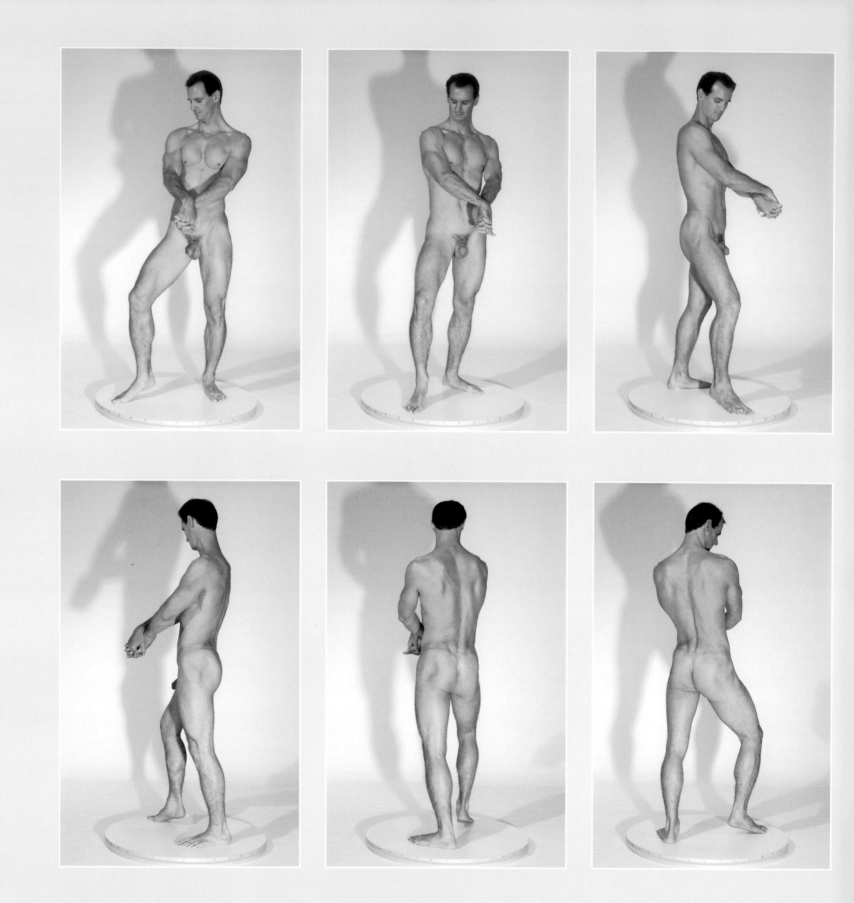

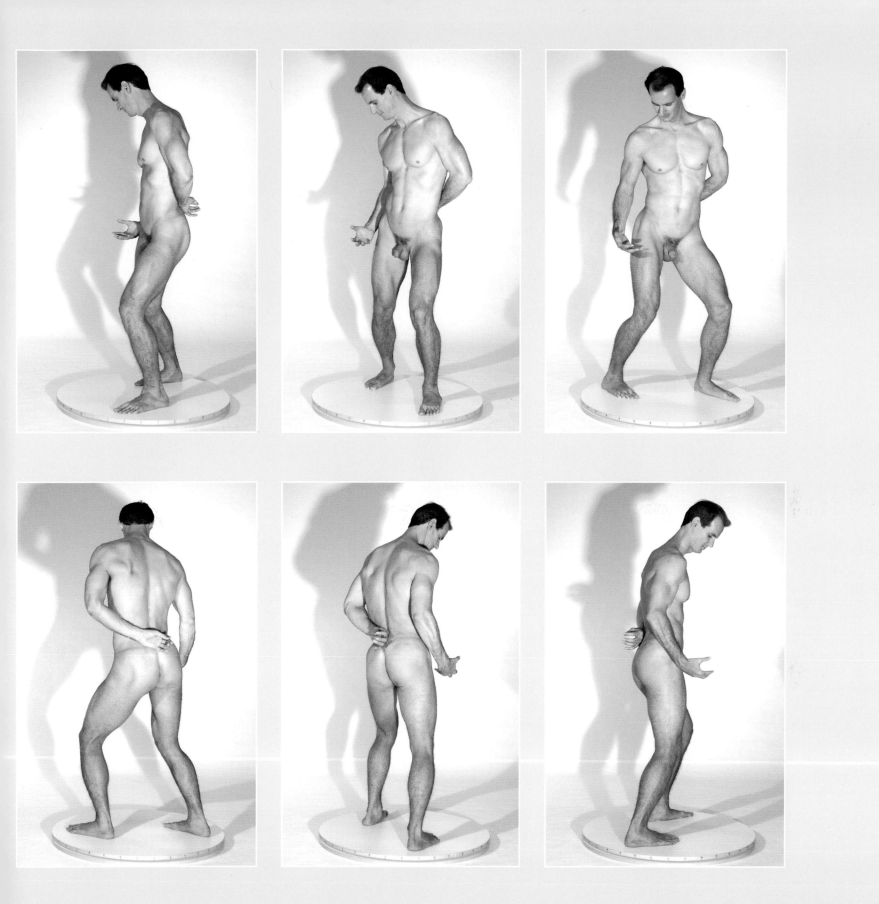

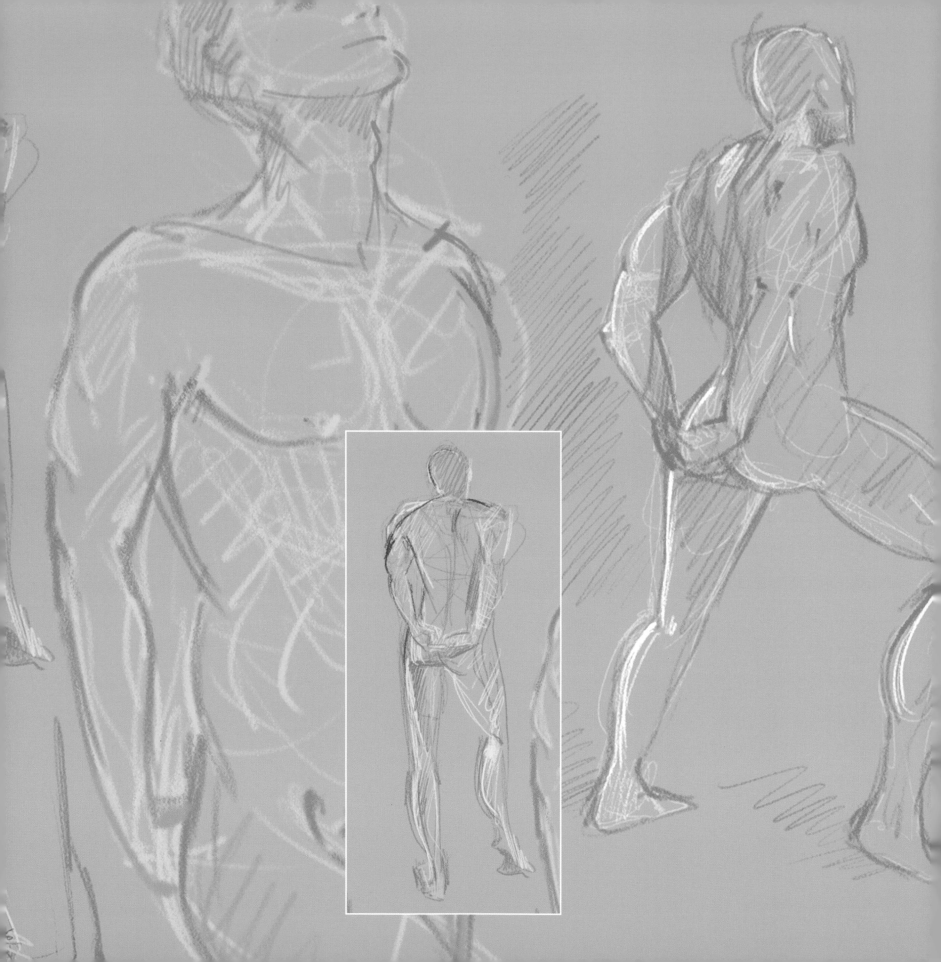

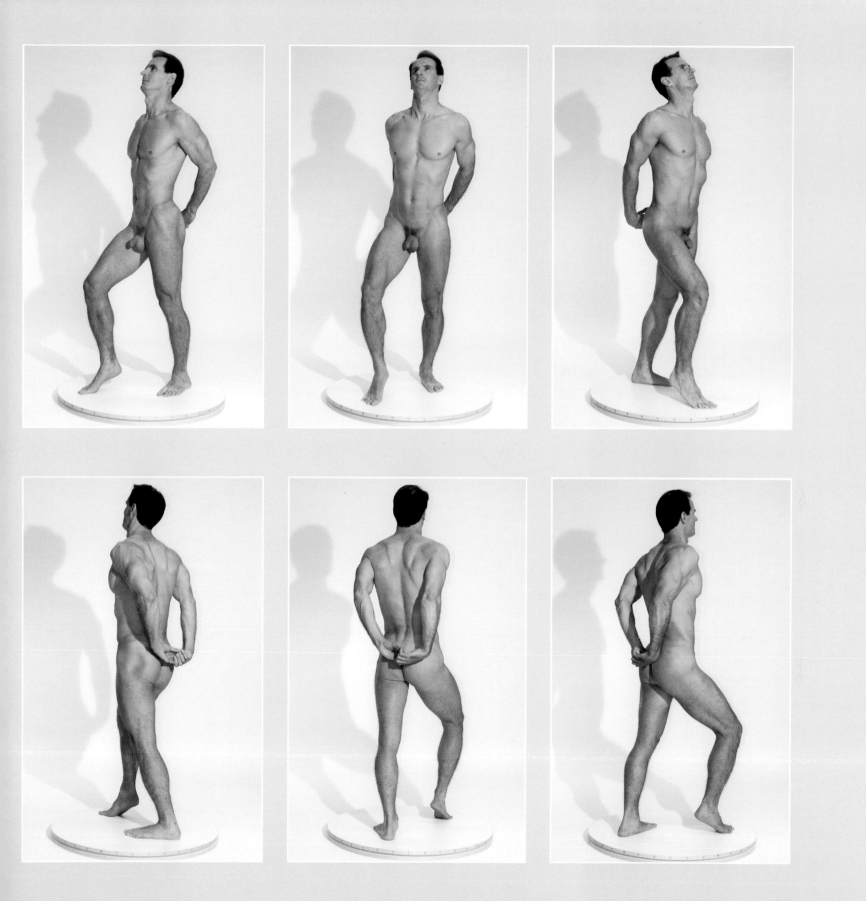

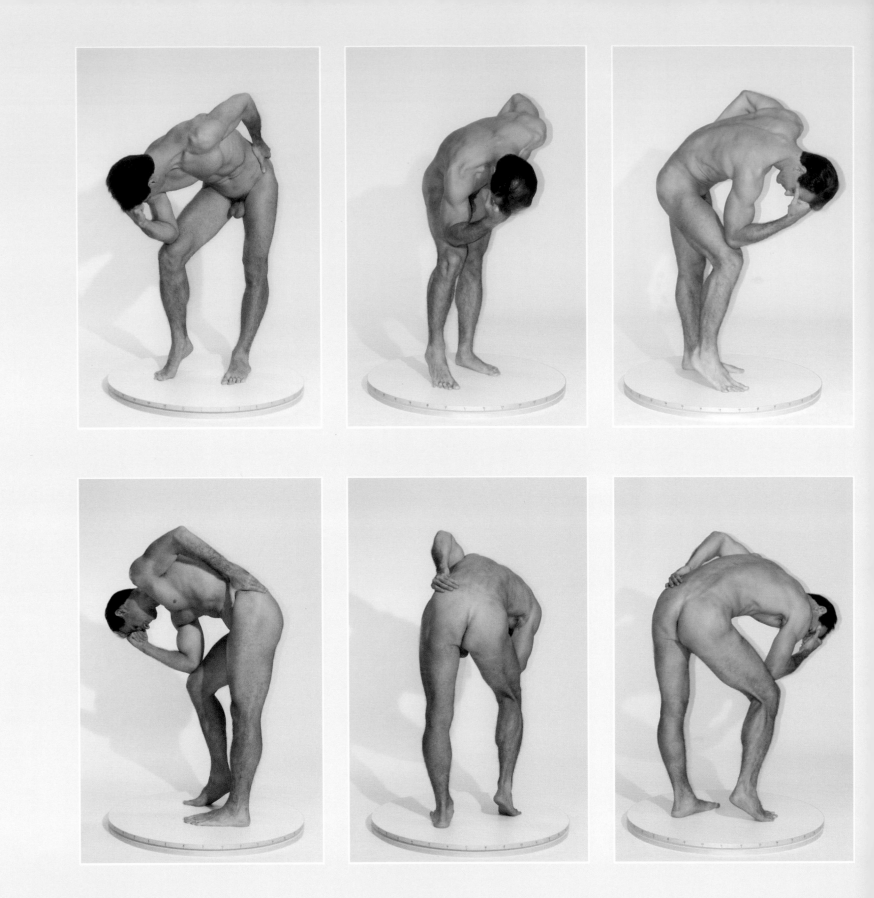

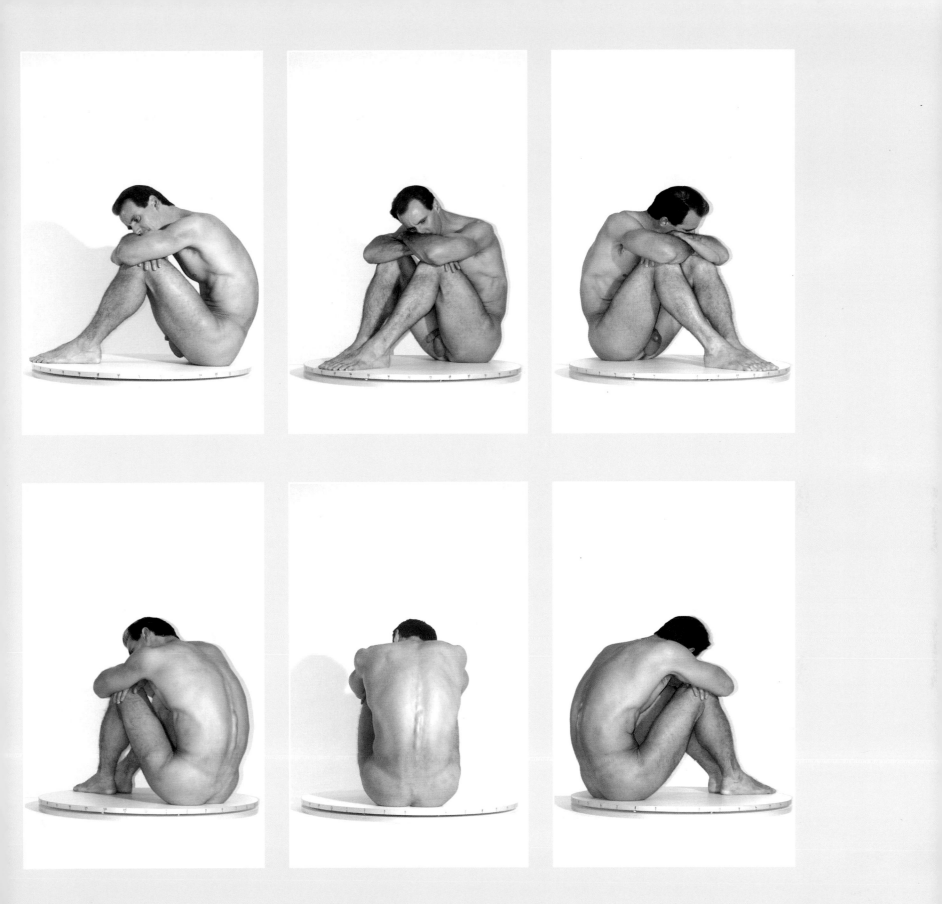

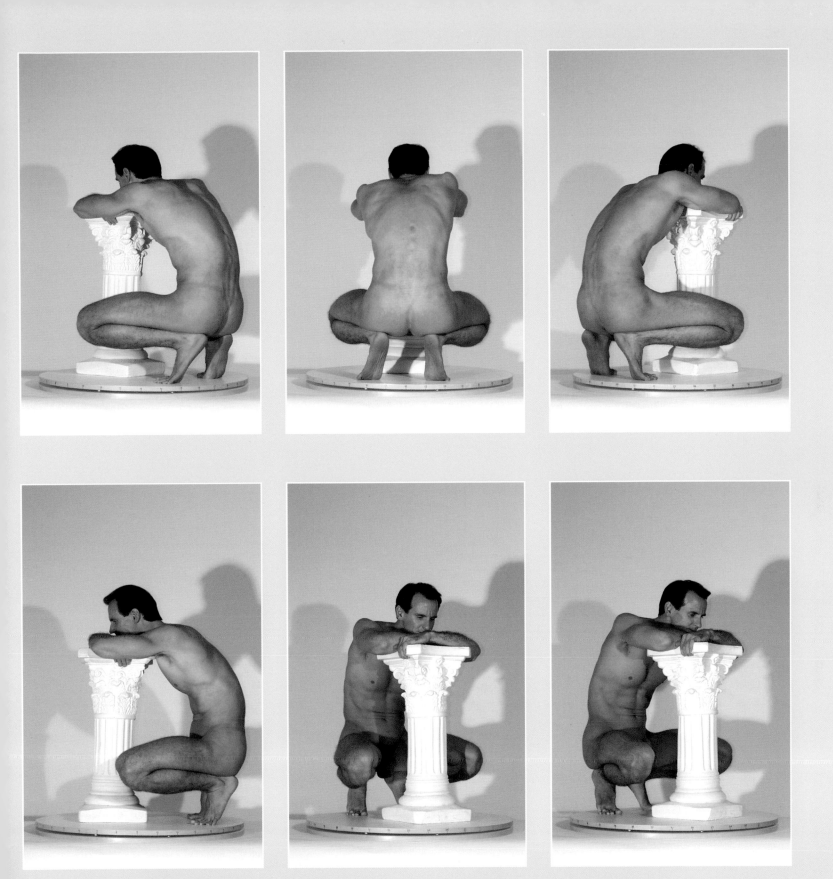

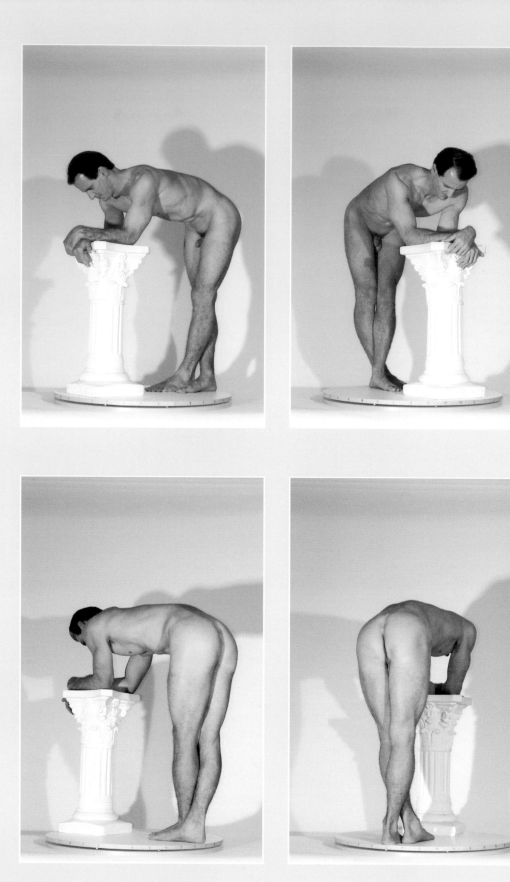
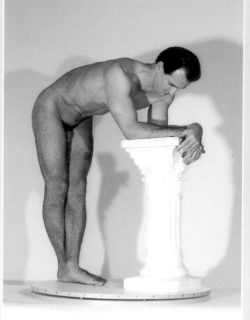
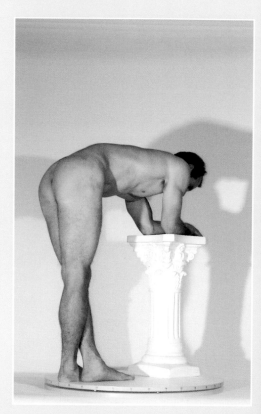

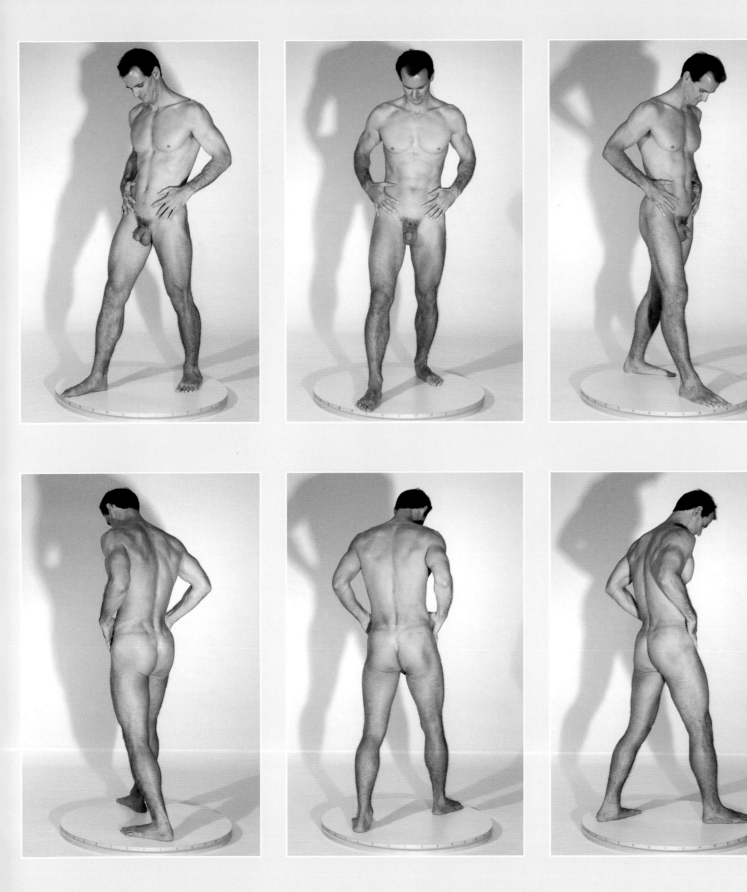

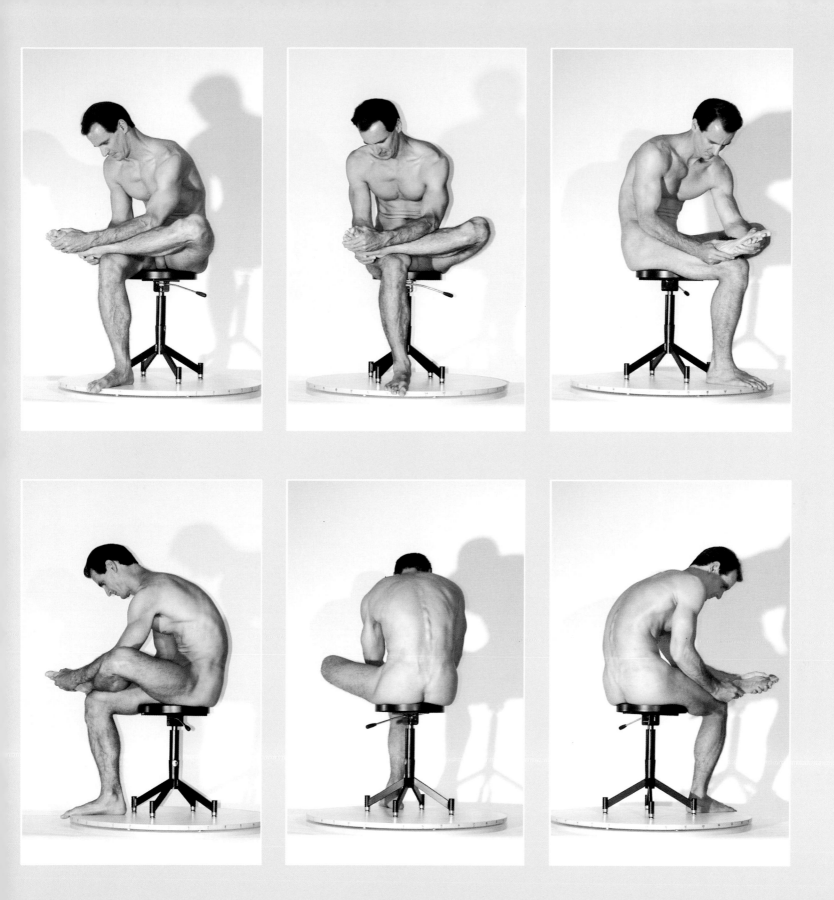

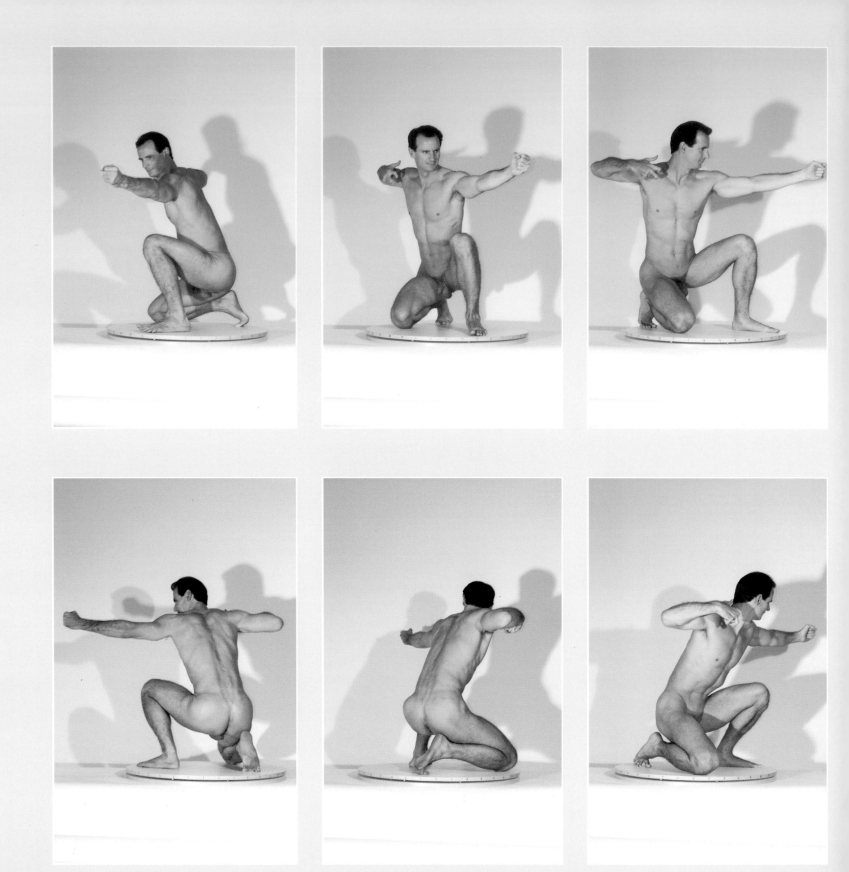

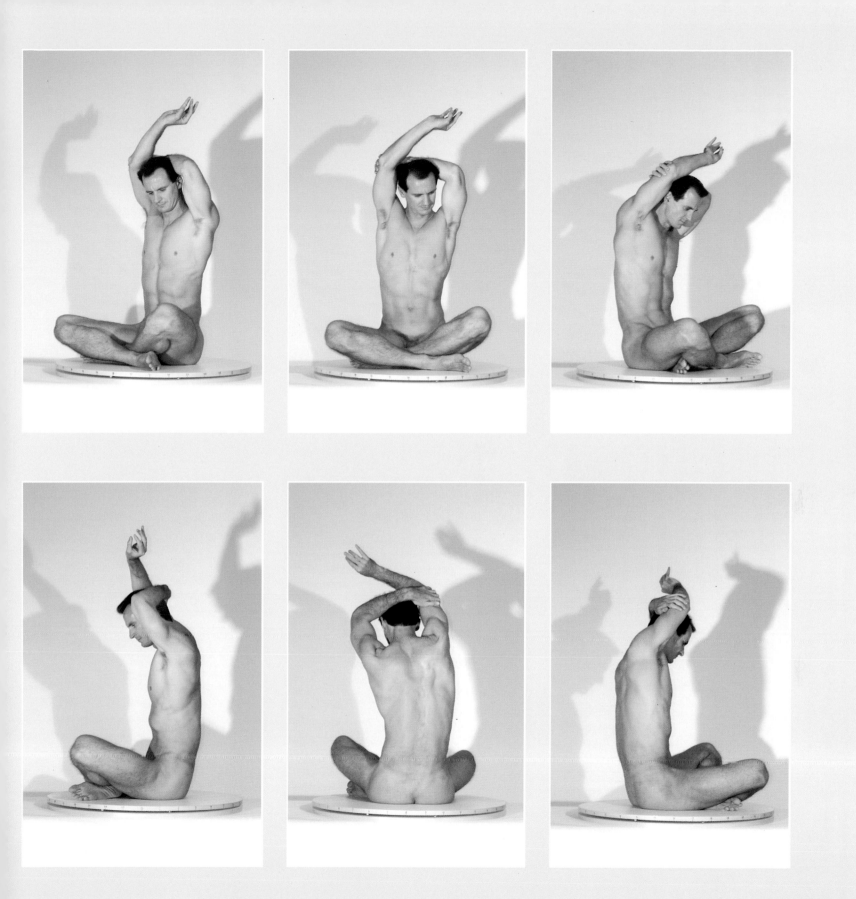

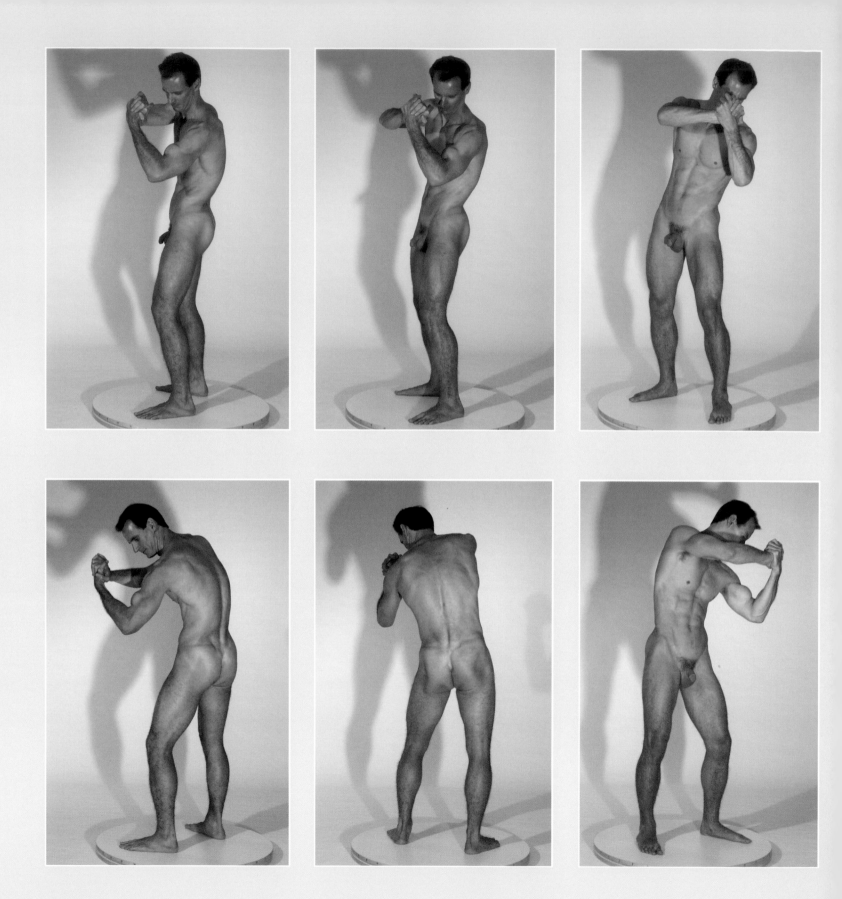

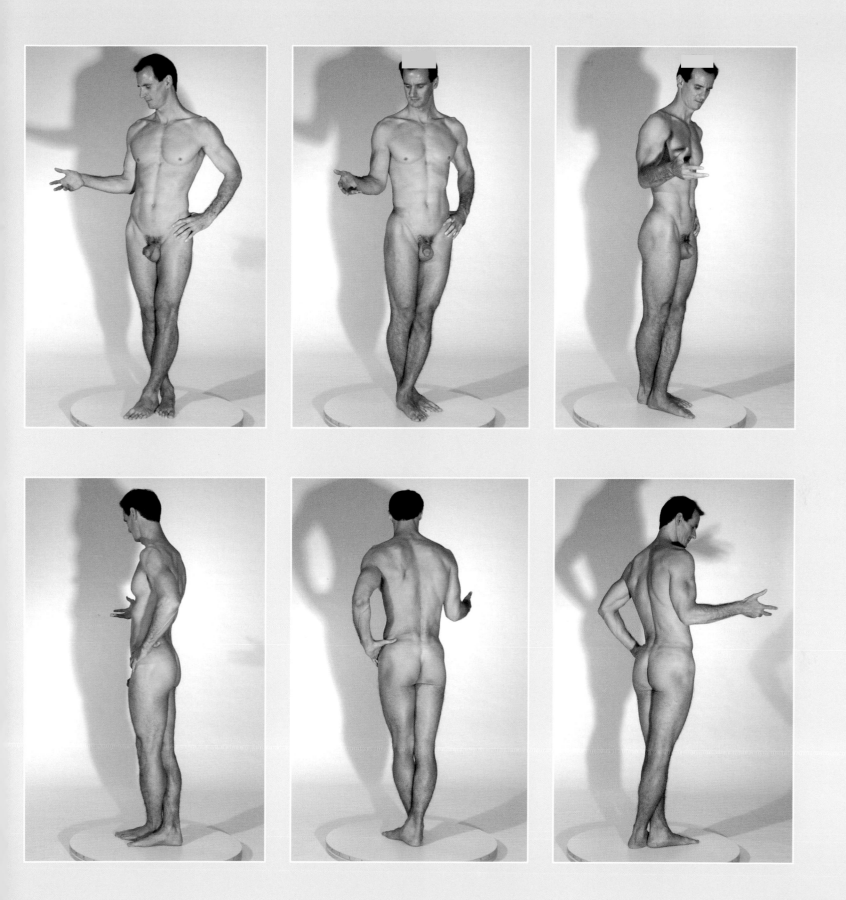

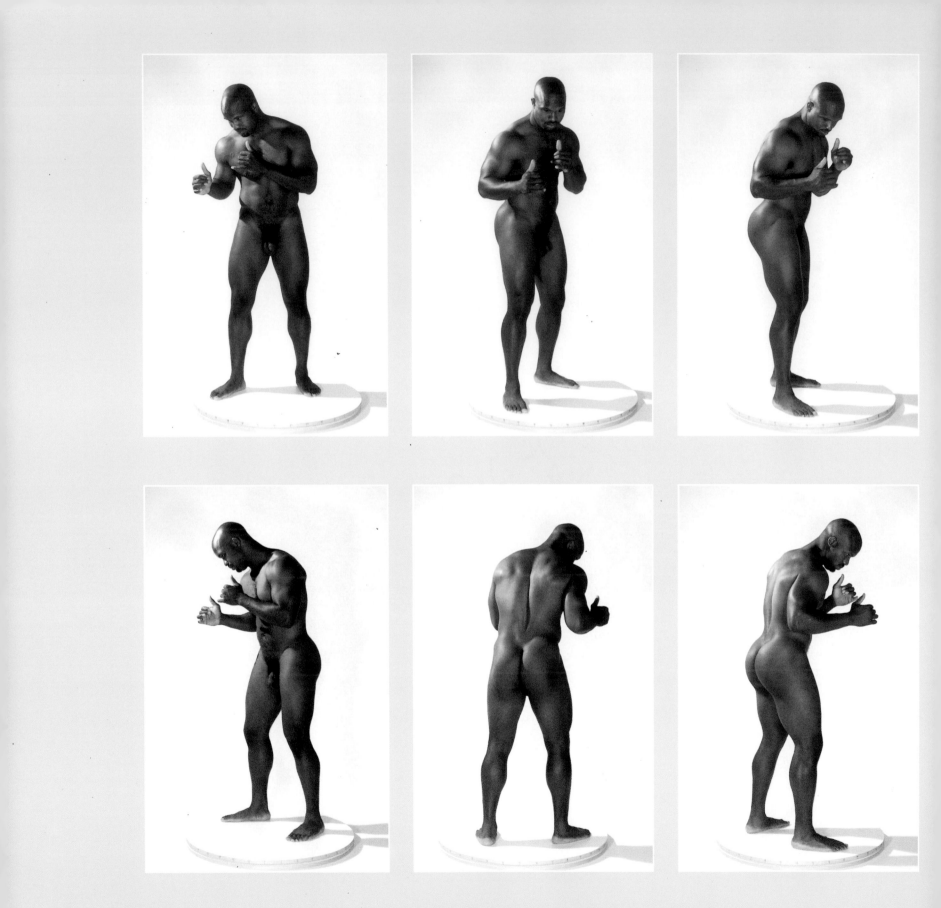

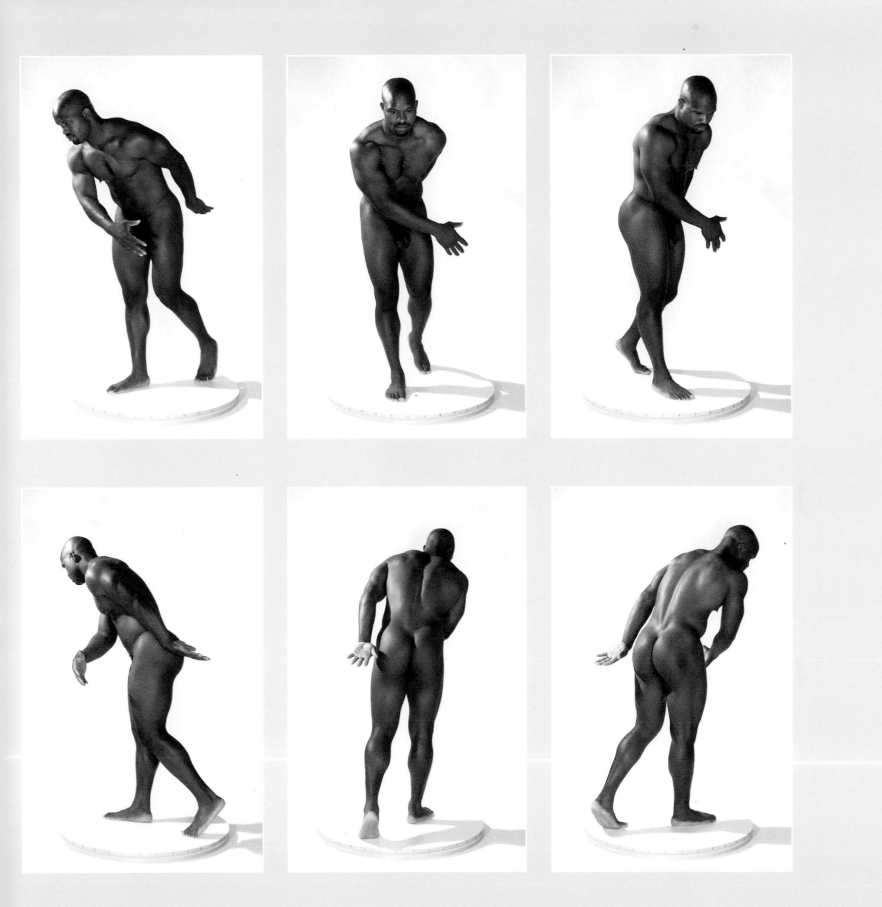

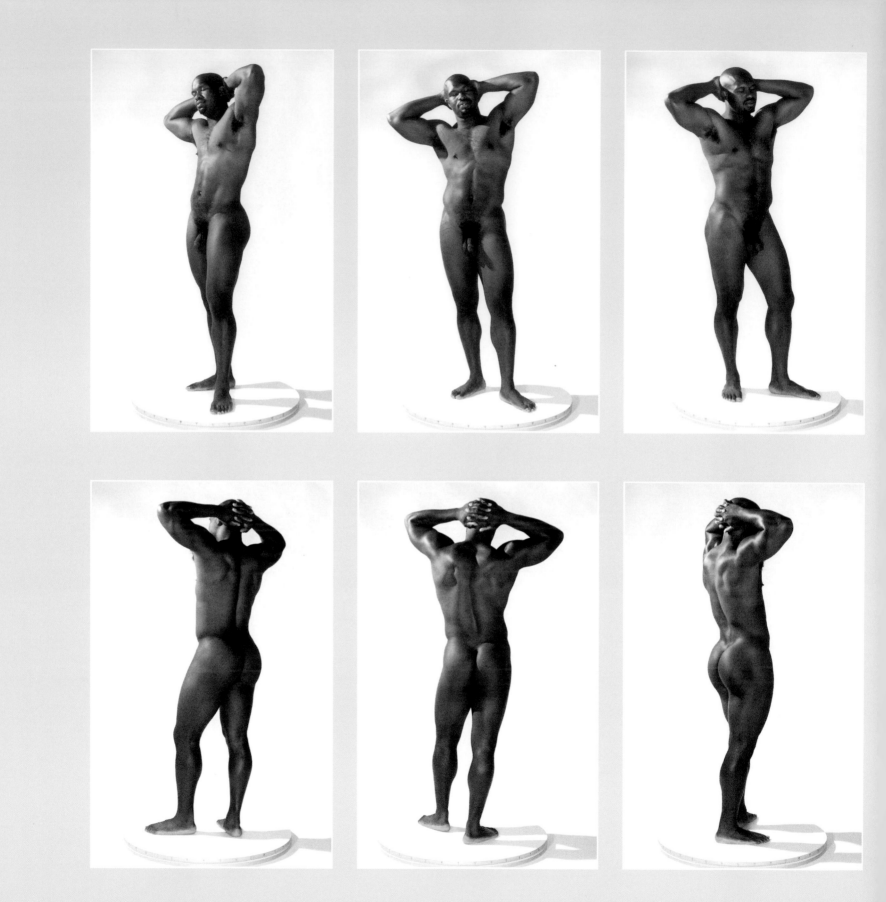

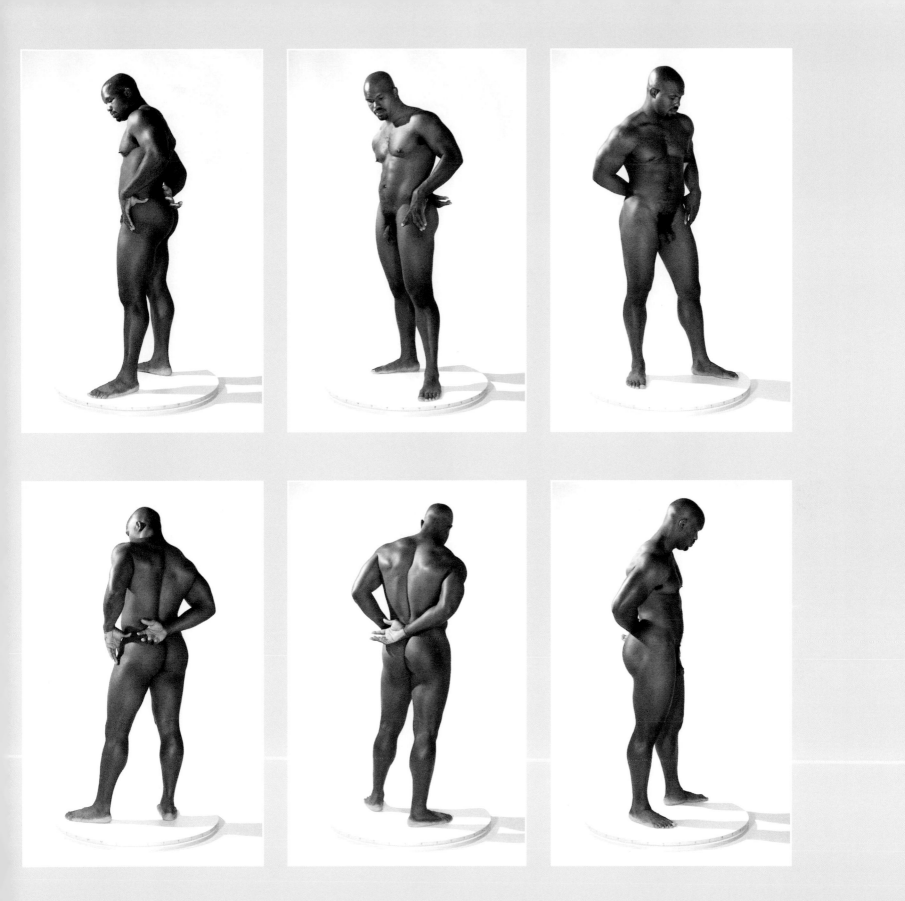

How to Launch CD:

For Mac: Double-click "VirtualPose2" icon. Follow instructions on your screen.

For Windows: CD-ROM will AutoLaunch "VirtualPose2.exe" application. To re-launch, double-click CD-ROM icon. With AutoLaunch off, from the Windows 95/98/NT4.0 "Start" button, select "Run." Type "d:\VirtualPose2.exe" press "Enter" (where "d" is your CD-ROM drive letter.) Follow instructions on your screen. Please view "ReadMe.txt" file

Once the CD launches and the opening credits are done playing, you will be taken to the "nerve center" of VIRTUAL POSE. There, the interface consists of 2 parts. On the right side, you have a selection keypad. On the left side, the stage where the poses will be displayed.

You will note that in the selection keypad (right side) both "MODELS" and "1" buttons are depressed and nine pose thumbnails are displayed. You will also note that the top-most left pose thumbnail is selected (depressed) with the corresponding pose in the stage on the left. To view the full catalog of poses, simply press on buttons "1" through "6."

You have fifty-four poses in total.

To rotate the model, simply position the cursor in the middle of the screen, click the mouse and drag to the left or to the right. (If using a tablet and digitizing pen, press the nib on the surface of the tablet and drag to the left or to the right)

You also have the option to zoom in and out, as well as reposition the pose after zooming and rotating in zoom mode.

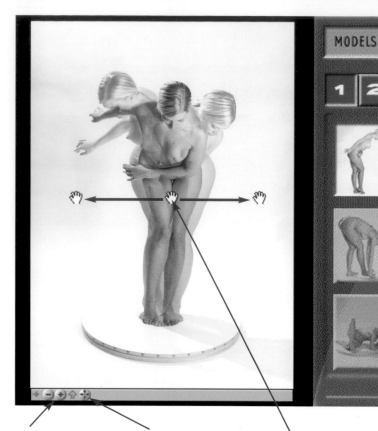

Magnification Tools
To enlarge the size of the pose, click on the icon with the " + " sign.

To reduce the size of the pose, click on the icon with the " – " sign.

Drag Tool
To move the pose within the window, once magnified, press once on the Drag tool icon. The cursor will turn into the Drag tool. Position the Drag tool over the pose, click and drag. Release. To rotate pose again, press on the drag tool icon again. Cursor turns to hand once repositioned over pose. Click and Drag to the left or right to rotate.

Cursor Tool
Cursor turns to hand once positioned over pose. Click and Drag to the left or right to rotate.

(If using a tablet and digitizing pen, press the nib on the surface of the tablet and drag left or right).

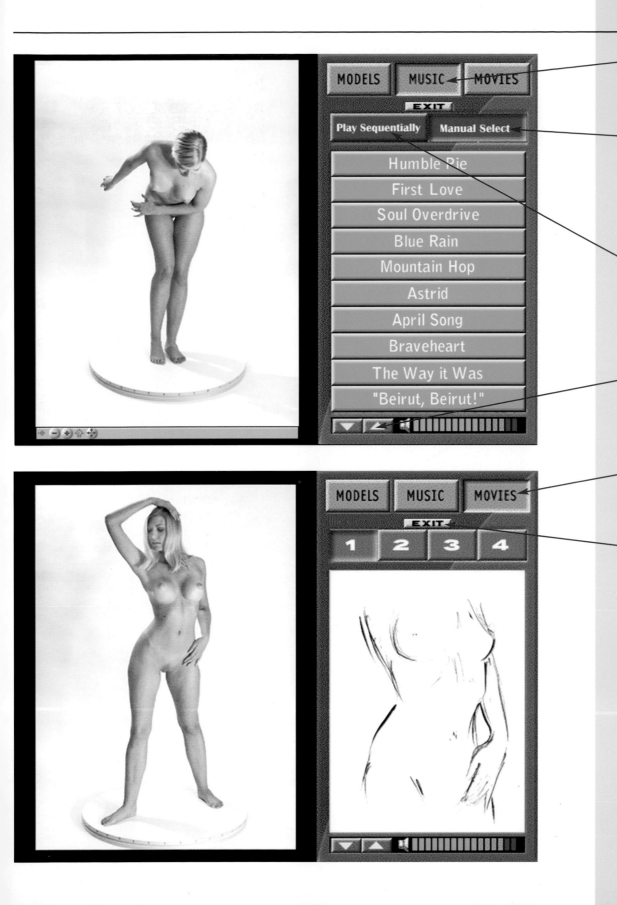

Once a pose is selected, click on MUSIC and, choose one of the two listening modes at your disposal.

Choose MANUAL SELECT to play the music randomly. Simply click on the theme and it will play. Once the piece of music is finished playing, you may choose another selection or the same piece will loop. If you wish to play the whole collection in sequence . . .

Choose PLAY SEQUENTIALLY. While the music is playing, you may rotate and zoom the pose. To choose a new pose, you will need to click on MODELS again and repeat the process.

When in MUSIC and MOVIES mode, two volume control buttons will appear to allow you to set the volume to a comfortable listening level.

To preview the tutorial MOVIES, press the MOVIES button. You have four movies to choose from.

To end the session, press on the EXIT button.

Minimum System Requirements:

MAC: Power Macintosh. 32 Mbytes RAM. 256 color. 4X CD-ROM Drive. System 8.5 or higher

PC: Pentium 200MHz processor. 64 Mbytes RAM. SVGA 640x480. 256 colors. 10X CD-ROM Drive. Sound Blaster or Compatible Sound Card and Speakers. Direct X version 3.0 or Higher recommended. Windows 95. Windows 98. or Windows NT 4.0

Produced by StudioView Interactive, LLC.

acknowledgements

I would like to thank the following people and organizations for lending their time, support and resources:

Design Books International	Alice Marie
Mirella Monti Belshé	James Marino
Matus Betko	David Miller
Stephen Bridges	Alana Neis
Michael Cardaci	North Light Books
Robert Estry	Dewey Reid
Joel Finch	Rebecca Segerstrom
Arthur Furst	John Sledd
Jennifer Grover	Susumu Sato
Dr. Jon Holstine	Donald and Janet Traynor
Imaging Zone	Laurie Wallace
Ruzena Jelinkova	Christopher West
Kimberly Kelley	Corinne Whitaker
Dennis Leviticus	Mark Wilkins
Missy Loewe	Keely Williams

My wife for her support, patience and love.
My partner, producer, collaborator and mentor, without whom none of this would have been possible: Gregory Scott Wills.
Last but not least, all the artists who invested in Virtual Pose 1; I especially would like to thank all those who took the time to express their opinions and whose valuable feedback played a vital role in shaping Virtual Pose 2.

We dedicate "Blue Rain" to the memory of Janel Sledd.